CHAPEL-EN-LE-FRITH

THROUGH TIME

Mike Smith

AMBERLEY PUBLISHING

Winter snow falls were once a common occurrence in Chapel-en-le-Frith, but three decades of relatively snow-free years came to an end in the winter of 2009-10, when snow remained on the ground for several weeks. Church Brow, the town's most picturesque street, took on an added beauty and the temporary resident in the left foreground of the photograph remained in place for some time.

To Jo-Ann, for your help, advice and forbearance
during the preparation of this book

First published 2010

Amberley Publishing Plc
Cirencester Road, Chalford,
Stroud, Gloucestershire, GL6 8PE

www.amberley-books.com

Copyright © Mike Smith, 2010

The right of Mike Smith to be identified as the
Author of this work has been asserted in
accordance with the Copyrights, Designs and
Patents Act 1988.

ISBN 978 1 84868 684 7

British Library Cataloguing in Publication Data.
A catalogue record for this book is available from
the British Library.

Typeset in 9.5pt on 12pt Celeste.
Typesetting by Amberley Publishing.
Printed in the UK.

Introduction

Chapel-en-le-Frith was founded in 1225, when foresters in the Royal Forest of the Peak were given permission by the Earl of Derby to build a chapel in the forest (a chapel-en-le-frith). The settlement that grew up around the foresters' chapel developed into a market town and an important stopping place on cross-Pennine routes. It would go on to play a major role in the development of transport, with the construction of one of the world's earliest tramways to haul limestone from the quarries at Dove Holes to the canal basin at Bugsworth, the building of two great curving viaducts to carry trains across the Blackbrook Valley and the establishment of the Ferodo works, where revolutionary brake blocks were manufactured for use in vehicles around the world.

Evidence of all these historic roles is still to be found. An ancient market cross stands in the cobbled market place and there is a remarkable concentration of former coaching inns at the core of the town. Vestiges of the eighteenth-century tramway remain, great viaducts still sweep across the Blackbrook Valley and Chapel-en-le-Frith is still known as the 'Home of Ferodo', as well as the 'Capital of the Peak'.

However, like every other town in the country, Chapel-en-le-Frith has witnessed a massive change in lifestyle during the last half century. Universal car ownership has not only enabled people to commute to jobs outside their home town, but has also brought about a profound change in their shopping habits, with daily trips to local shops being replaced by one-stop visits to a supermarket. The rise of television has caused many local cinemas to close and getting in touch by letter and postcard has been superseded by instant communication via email and mobile phone. Greater affluence has led to a demand for bigger and better houses, and labour-saving devices have removed much of the drudgery from day-to-day living. People have more leisure time, longer holidays and greater educational opportunities.

As the photographs in this book demonstrate, all these changes in lifestyle have had an impact on the physical appearance of the town. There are far more cars, streets have become festooned with road markings, yellow lines, parking bays, traffic-calming projections, road signs and traffic lights; there are more supermarkets and fewer local shops; green fields have been covered in new housing estates; the town's only cinema has been demolished; brand new schools and a state-of-the-art leisure centre have been built and the grounds of a former country house have been converted into a wildlife park and visitor attraction.

Although these changes are very obvious, the retention of so much of the town's ancient fabric is also very apparent. Almost no buildings of historical significance have been lost; the Old Town is wonderfully intact and the main streets have retained their overall appearance and suffered very few incongruous intrusions. In the last ten years, heritage grants have been used to restore traditional shop fronts and various regeneration projects have enhanced the appearance of the ancient core of the town.

In fact, continuity is very apparent in the story of Chapel-en-le-Frith, not only in the retention of its physical appearance as an ancient market town, but also in the preservation of its customs, clubs, societies and organisations. Brass bands, amateur theatricals, uniformed organisations, carnivals, morris dancing, male-voice and ladies' choirs, women's institutes, gardening clubs, a civic society and sports clubs of every description continue to flourish in the town. What is more, several newer activities, such as the May Day festivities, Well Dressing Week and Proms in the Park, have already become firmly established as annual events.

Continuity of physical appearance is apparent in the picturesque hamlets that are to be found in the hills surrounding the town. These places are wonderfully unspoilt, even though their local inns have become popular eating places and many of their houses have been snapped up by commuters or rented out as holiday lets. The area around the town also contains a remarkable concentration of country houses, or 'halls', many of which date from the days of the Royal Forest of the Peak. They too have retained much of their original appearance.

As the photographs in this book show, the story of Chapel-en-le-Frith is about continuity, as well as change.

Origin Unknown

Chapel-en-le-Frith's gaunt and weathered Market Cross stands at the south-eastern corner of the Market Place. There are disputes about its age, with some historians suggesting that it may have originated as a thirteenth-century preaching cross, perhaps as a focus for open-air services on market days, and others making rather far-fetched claims that an inscribed date of 1636 could once be detected on its rough surface. In 1936, when the main road was widened to cope with increasing traffic, the railings on the perimeter of the raised Market Place were squeezed right up to the monument, leaving it in a rather cramped situation. The railings now support colourful planters, and the stepped podium of the cross is set in stone flags, rather than cobbles. The street scene has also changed, with a mock half-timbered edifice making an appearance on the corner of Rowton Grange Road and a new building for the Nat West Bank replacing the premises of the District Bank at the corner of the Market Place. The cross itself remains largely unchanged, despite the relentless attacks on its stonework by the Peak District weather.

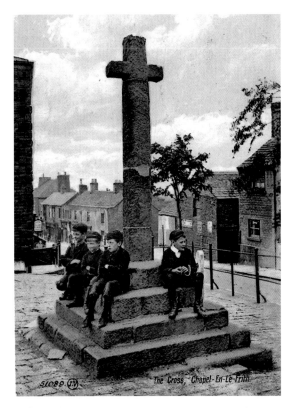

The Cross, Chapel-En-Le-Frith

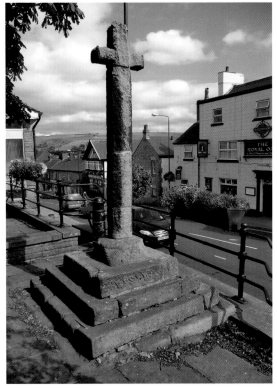

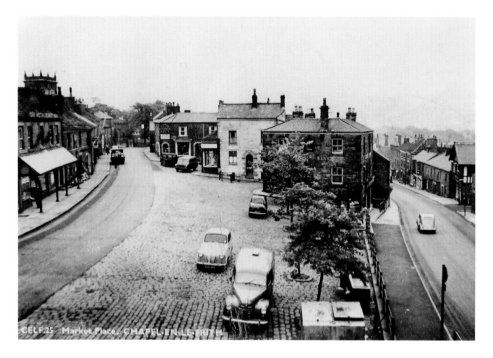

Room with a View

Room 9 of the King's Arms commands a fine view over the Market Place, which was cobbled in former years but is now partially paved, in order to quarantine the various monuments from the line of parked cars. Fifty years ago, regimented parking was unnecessary and drivers could choose a parking spot with almost complete abandon. The most noticeable change in the built environment is the replacement of the four-square District Bank with the gabled NatWest Bank.

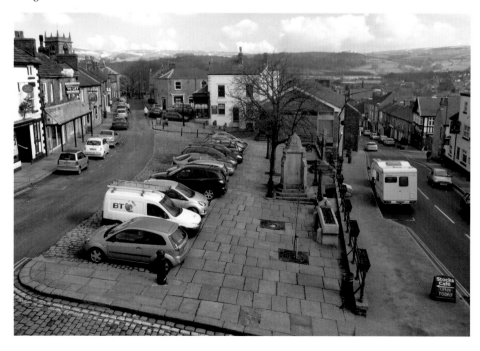

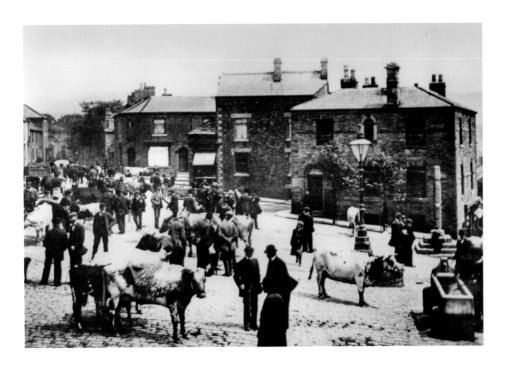

Market Forces

Chapel's cattle market, which was held on the first Thursday of each month, is long gone, but the tradition of a Thursday stall market continues to this day, albeit in much reduced form. There was a time when stall-holders would defy the most extreme weather conditions to sell their goods, but the number of stall-holders has fallen dramatically in recent years. Consequently, Chapel-en-le-Frith's weekly market consists of very few stalls, even on fine days.

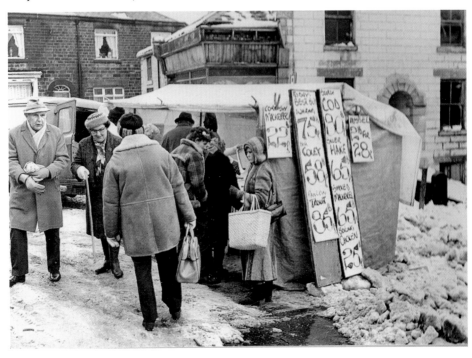

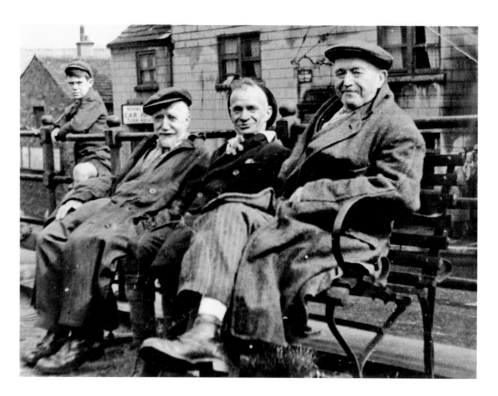

Watching the World go by

The public seat next to the Market Cross has long been a favourite spot for gathering and watching the world go by. The three men in the old photograph are residents of The Elms, which was founded as a workhouse. Although the present seat occupies the same spot, it faces the road rather than the Market Place. The recent photograph shows Sarah Baxter, Emma Bennett, Charlotte Smith and Hannah Lord, who have gathered on the seat before a night out.

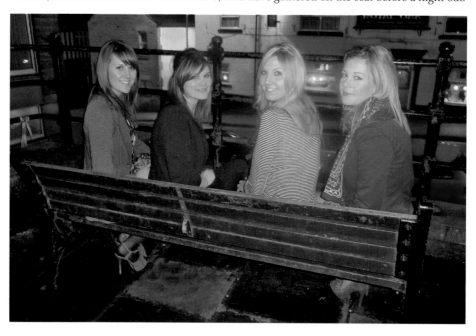

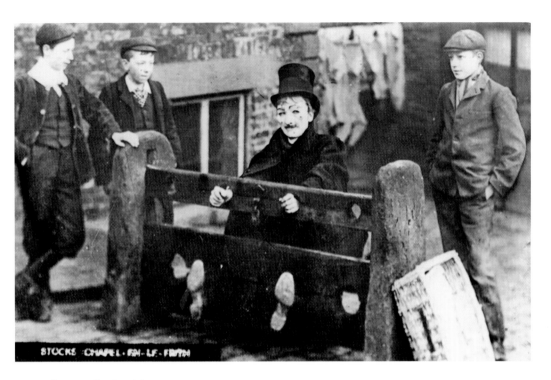

STOCKS CHAPEL-EN-LE-FRITH

Gluttons for Punishment

The stocks are said to date from the Cromwellian period. It can't have been much fun for miscreants who were locked in them in the days when they were used for punishment by public humiliation, but people are now inclined to see them as a source of amusement. In the lower photograph, the author is about to be drenched by his daughter in a publicity shot taken in 1996 as part of an appeal for artefacts for the Heritage Centre.

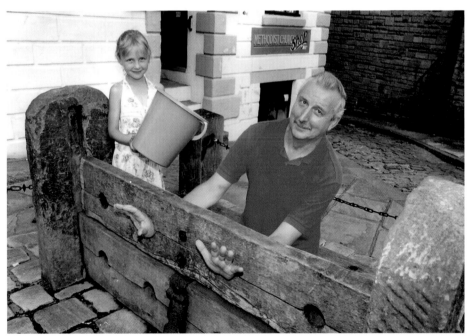

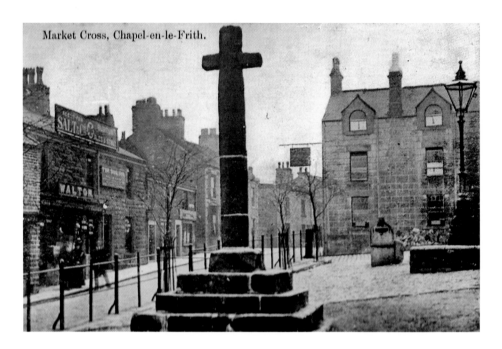

Market Cross, Chapel-en-le-Frith.

Monuments Past and Present

The triple-gabled King's Arms was a stopping place on the Buxton-Manchester turnpike in the coaching days. The horse trough, visible in both photographs, was erected in 1897 to celebrate Queen Victoria's Diamond Jubilee; the War Memorial, which features in the lower photograph, was erected by public subscription in 1919. Unusually, the memorial lists all the local men who fought in the Great War, not just those who died. The tall lamp standard was removed many years ago.

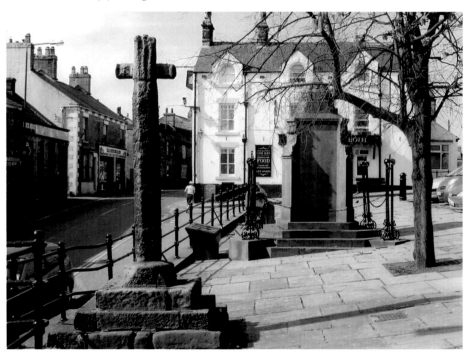

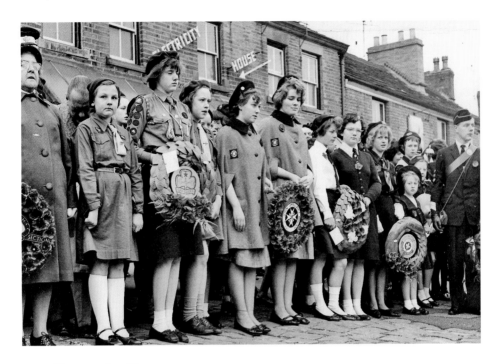

We will Remember Them

On Remembrance Sunday, there is a parade through the town by members of the British Legion and the various uniformed organisations, together with parish councillors and members of the public. The march is followed by a service at St Thomas Becket Church. Representatives of many local organisations then line up on the Market Place, in order to place their wreaths on the War Memorial.

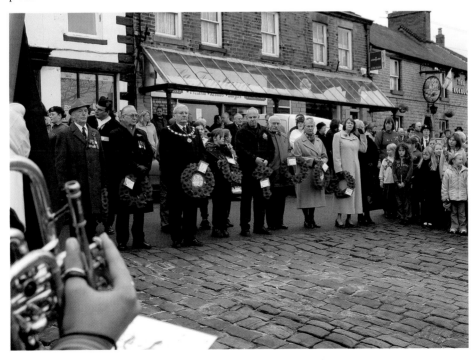

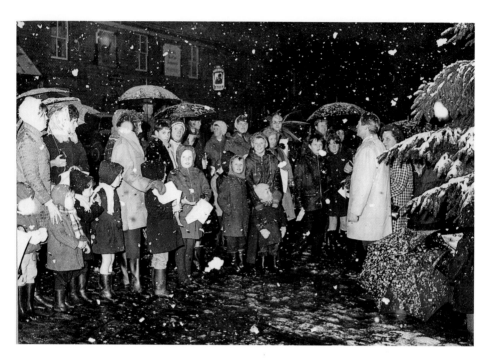

A White Christmas

The switching-on of the Christmas lights is celebrated by carol services next to the Christmas trees at Town End and the Market Place. These two events are linked by a procession through the town. Occasionally, the ceremonies are given added atmosphere by a fall of snow. Carnival Queen Hayley Young, Cllr. Ann Young, Parish Chaplain Rev. Derrick Leach and Cllr. Guy Martin, Chairman of the Parish Council, feature in a photograph of the switching-on of the lights in 2007.

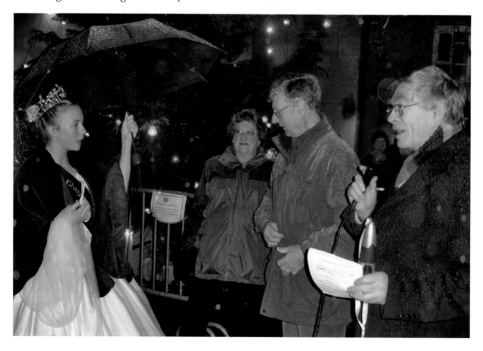

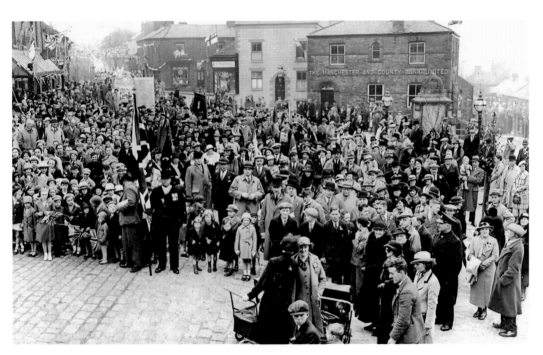

Mayday, Mayday

A large crowd gathered on the Market Place on 12 May 1937 to celebrate the Coronation of King Edward VIII. In recent years, May Day has been celebrated on the Market Place by a fun day for all the family, with stalls, children's rides and entertainers. This annual event was instigated by the Chapel Regeneration Partnership and is organised by Sue Stockdale, who is Clerk to the Parish Council, and by Caroline Gregory and several other members of the Chapel Traders' Association. The lower photograph shows the author, who is Chairman of the Regeneration Partnership, being greeted by a May Day entertainer.

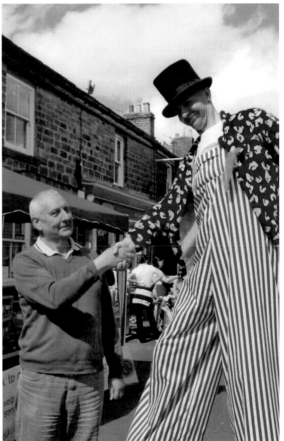

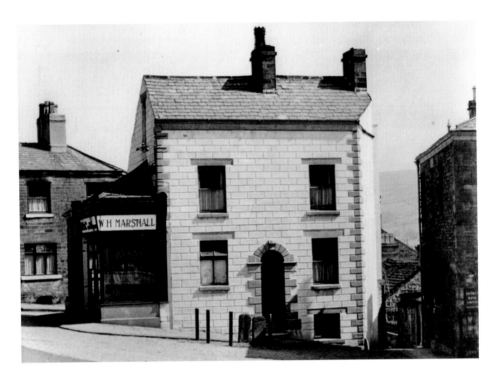

Main Street no More

The narrow lane on the right is Terrace Road, which was once the main thoroughfare through the town. The stocks are now mounted on a small plinth and surrounded by a chain, and the premises that traded for many years as Marshall's butchers are now occupied by the award-winning Stocks Café, which contains a mural by Claire Taylor depicting the cattle market in 1897. A new direction sign points visitors to the town's various tourist attractions.

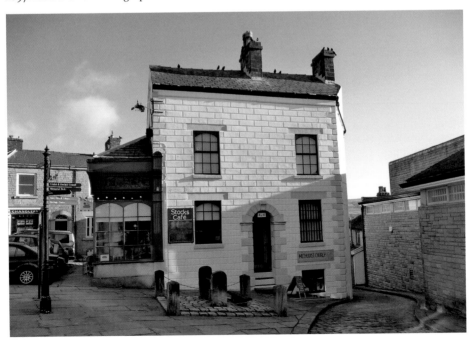

Up the Alley

The buildings of Chapel's 'Old Town' are clustered around Terrace Road, Church Brow and the alleyways that run away from the Market Place. These photographs, which were taken from Terrace Road, show the entrance to the alley known as Pickford Place. The shop on the left, which was the home of Jones' Music Shop, has been a delicatessen in recent years. When the recent photograph was taken, it was being converted into the Apple Tree Café.

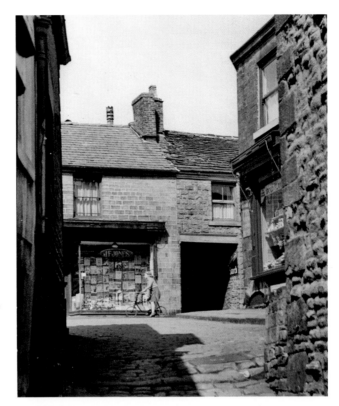

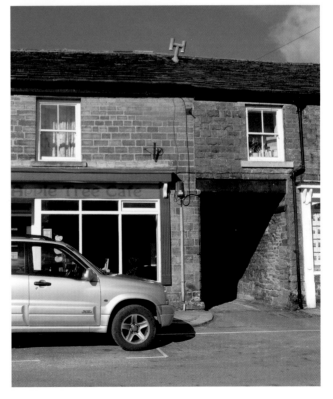

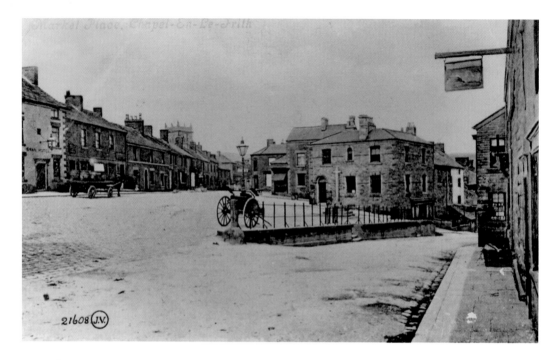

From the Dog

The Dog Inn was previously known as the Talbot, a reference to the hound that features on the coat-of-arms of the Earls of Shrewsbury, custodians of Mary Queen of Scots during her stay in Derbyshire. The earlier view from the inn shows the Market Place before the addition of the Jubilee Horse Trough in 1897. The Swan Hotel, on the left of the older photograph, has become the Post Office and the adjacent building, known as Carlton House, is now arcaded.

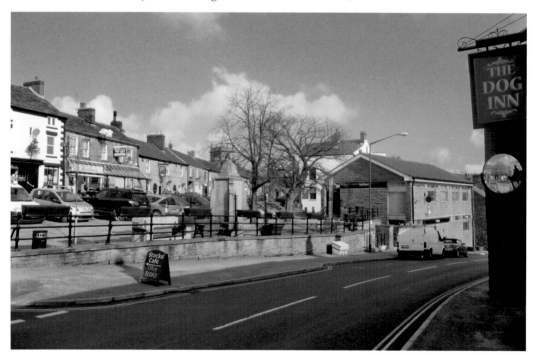

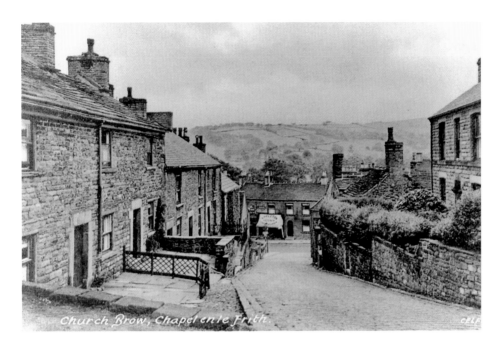

Church Brow, Chapel en le Frith.

Chapel's answer to Gold Hill

The steep cobbled street known as Church Brow links the parish church with Market Street. With its cottages arranged in echelon, it is the most picturesque street in town and Chapel's version of Shaftesbury's Gold Hill, famed as the location for a Hovis commercial. Most of its houses have a peculiar form of asymmetric decoration around their doorways and, as the lower photograph shows, some of them have been rendered in recent years.

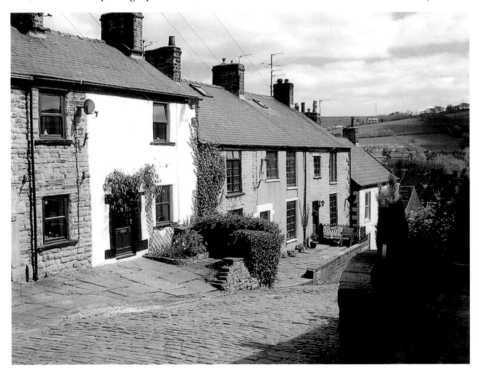

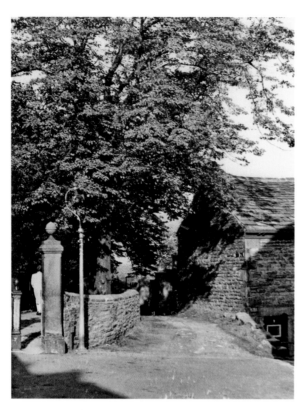

Stumped!

The area at the entrance to the churchyard is Dane's Yard. Stone pillars mark the beginning of a footpath that runs alongside a narrow road leading to Burrfields. The top half of one pillar and a small stump in the middle of the entrance to the footpath have both gone. Legend has it that the stump was removed after a cow became trapped between the stump and the pillar on its way to the cattle market.

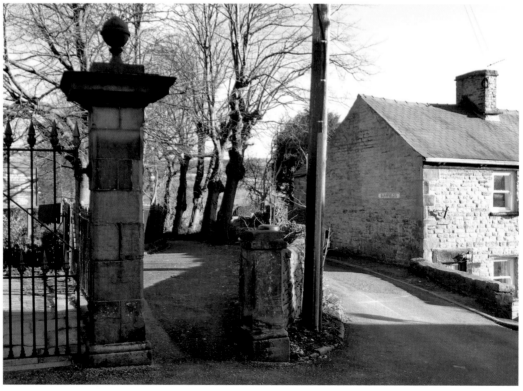

The Twelfth Apostle

The twelve trees that form a division between the path that runs alongside the churchyard and the road leading to Dane's Yard are known as The Apostles. Unfortunately, the last tree in the line has perished and has now been replaced by a sapling. The Bull's Head Inn, located just outside the church gates, no longer operates as a pub. Although it is now a private house, it retains an impressive carving of a bull's head above its elaborate fanlight, as well as a fine set of mounting steps.

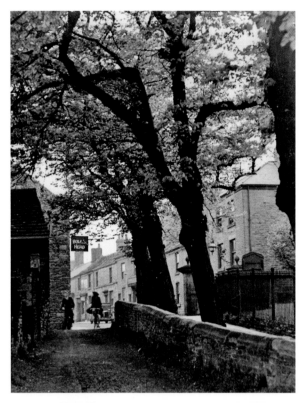

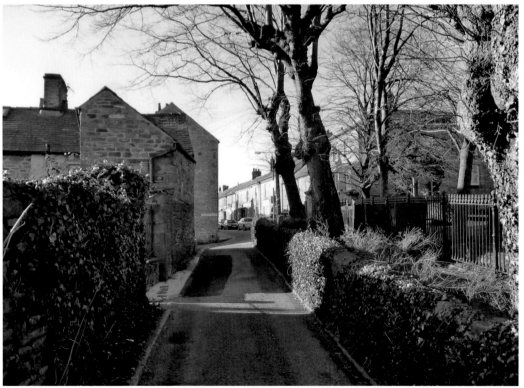

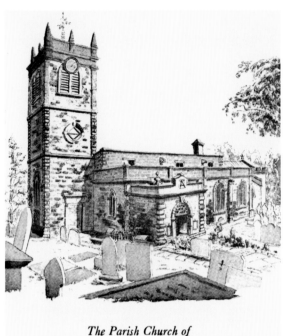

The Parish Church of

ST. THOMAS BECKET

CHAPEL-EN-LE-FRITH

The Chapel in the Forest

Chapel's church was founded in 1225, when the Earl of Derby gave foresters in the Royal Forest of the Peak permission to build a chapel in the forest (a chapel-en-le-frith). The foresters dedicated their chapel to St Thomas Becket, who had been murdered in Canterbury Cathedral in 1170. Exactly five years to the day before the consecration of Chapel's church, Becket's body was moved to a specially constructed shrine in the cathedral. As the cover of an old guidebook shows, the vicars of Chapel have always used the English version of the Saint's name, rather than the French version of St Thomas à Becket. The recent photograph reveals that the stonework was poorly faced during the rebuilding of the south side of the church and the tower in 1733. Extensive restoration work has had to be undertaken on the tower in recent years.

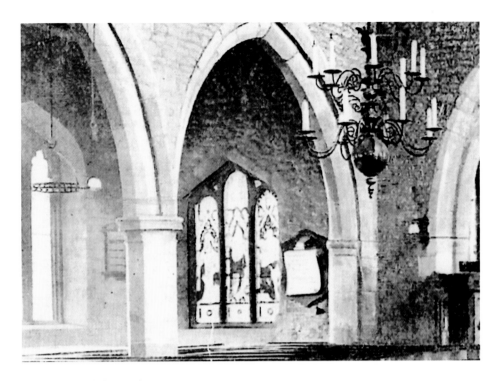

The Light and the Dark

The darkest episode in the church's history took place in 1648, when 1,500 soldiers taken prisoner by Cromwell's forces at the Battle of Ribbleton Moor were locked in the building for two weeks. When the doors were opened, forty-four men were found to be dead. The new window at the head of the south aisle, which seems to be emitting its own light, was designed by David Pilkington as a replacement for a window that had been destroyed by fire.

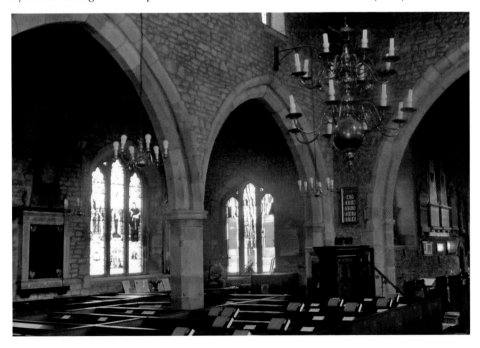

A Stream of New Housing

Until recent years, Smith Brook meandered along the foot of a swathe of green land known as Burrfields. It now runs through a new housing estate called Hayfield Park, which was built shortly after the construction of the Danesway estate on land to the south of Burrfields Road. Surprisingly, the plethora of new housing in the town has not brought about a huge increase in the population. This is because there are now fewer occupants per dwelling.

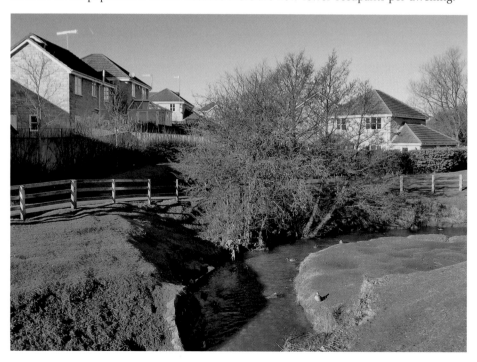

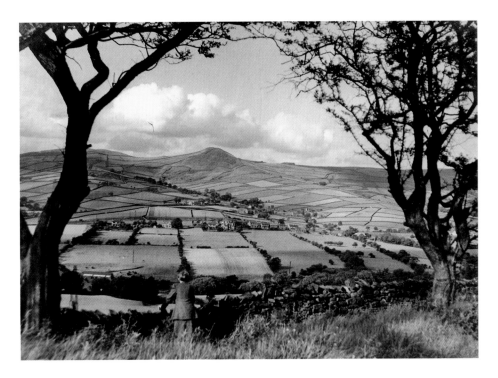

A Peak in the Peak

The landscape views from the Burrfields area are dominated by South Head, one of the very few genuine peaks in the Peak District. These photographs, taken from the northern boundary of the town, show how the natural contours of this shapely hill, which stands on the rim of the vast Kinder Scout plateau, are picked out and emphasised by the stone walls that run across its slopes. The neighbouring summit is Mount Famine.

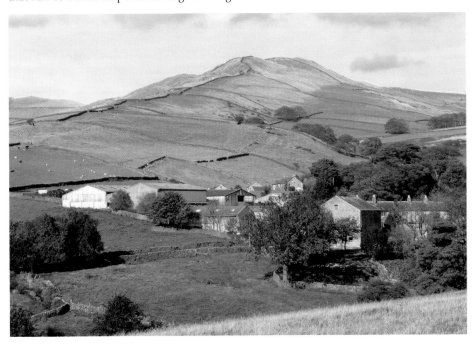

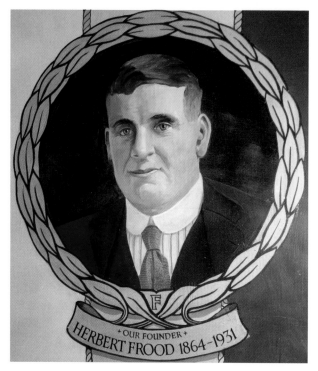

HERBERT FROOD 1864-1931
+OUR FOUNDER+

Putting a Stop to Ragged Brakes

When Herbert Frood became alarmed by the 'untidy and ragged' brakes on wagons negotiating the steep hills of the Peak District, he determined to find something better. On a visit to his father-in-law's belting factory, he found some discarded oil-soaked belts. After experimenting on them in a makeshift laboratory in a hut at the foot of his garden, he found that they had excellent friction properties. Having hit upon the idea of using oil-impregnated woven cotton as a braking material, he set up his own braking factory at Gorton in 1897. Dubbed Ferodo, an inaccurate anagram of the founder's name, the factory moved to Chapel in 1902. Frood's garden hut is preserved in the grounds of the works.

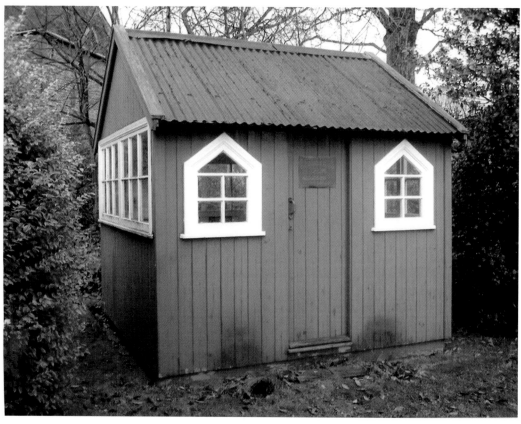

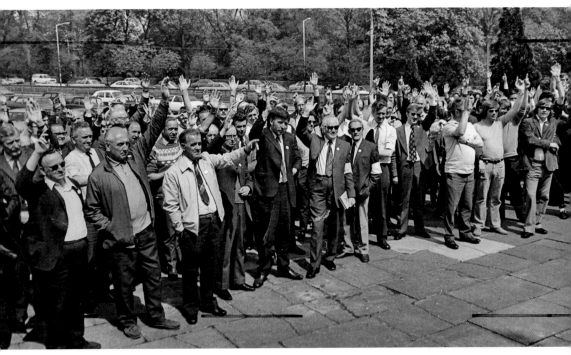

The Home of Ferodo

In the seventies, strikes were a common occurrence throughout the country. This one took place at the Ferodo works in 1974. The size of the workforce at the factory has been drastically reduced over the years and Ferodo is now owned by the American company Federal Mogul. However, the original trade-name is still used by the new owners, which means that Chapel-en-le-Frith is still entitled to be called 'The Home of Ferodo', as well as "The Capital of the Peak".

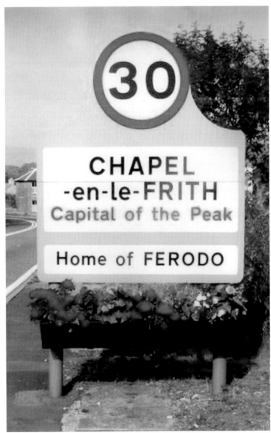

Drum and Monkey

The part of Bowden Lane that descends through a picturesque glade to Chapel Milton is known locally as the Drum and Monkey. The term may originate from a pub with that name or from a travelling trader who came into the area with his drum and monkey. Since 1987, the lane has been crossed by the high-level A6 bypass.

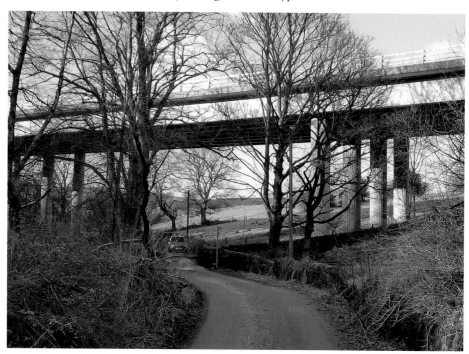

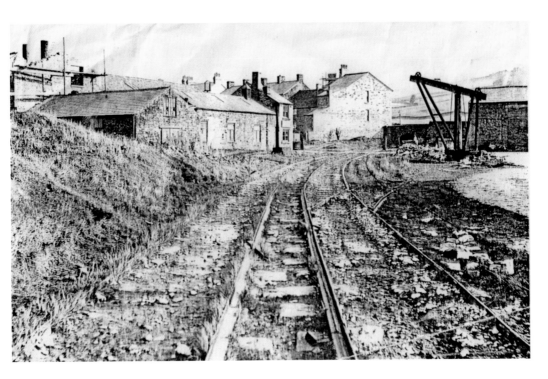

On Track

In 1796, a tramway was built to link the limestone quarries at Dove Holes with Bugsworth Canal Basin. The wagons were horse-drawn in all but the steepest section, where the weight of loaded descending wagons was used to haul up the empty wagons. In the upper picture, which dates from 1903, the incline can just be spotted beyond the Castleton Road tunnel. The tramway closed in 1926 and part of its path has now been developed as a walking trail.

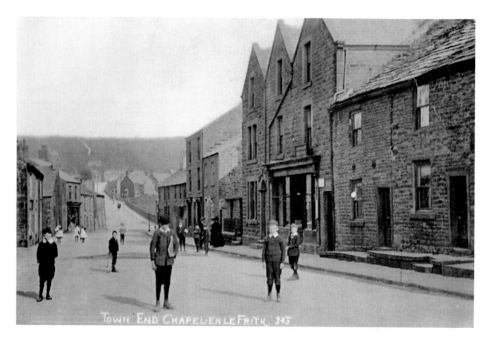

TOWN END CHAPEL-EN-LE-FRITH. 343

Dicing with Death?

If today's children were to emulate these youngsters from the early years of the twentieth century by standing in the carriageway at the foot of Buxton Road, they would be dicing with death, because the road now forms a link between the northbound carriageway of the A6 bypass and the centre of town. Although the volume of traffic has increased greatly, the buildings in this area of Town End have barely changed at all.

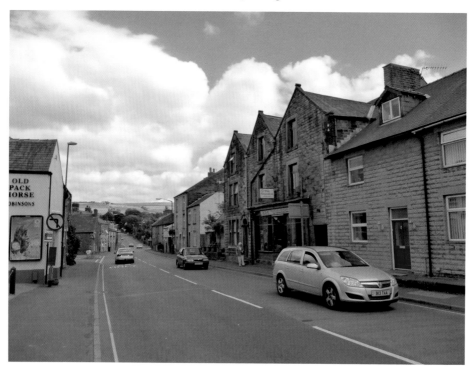

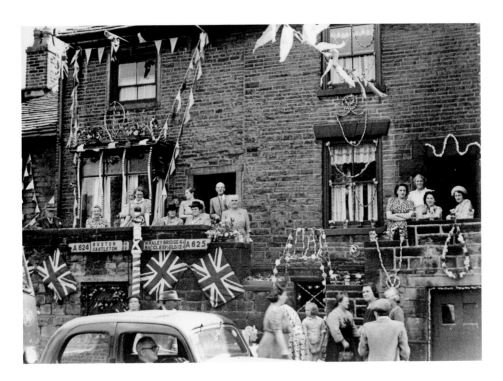

Grandstand View

The balcony of a house at Town End which gave these people a grandstand view of the VE parade in 1945 has now been encased in glass, but the first-floor entrance to the property remains. The signpost that greets motorists arriving at the top of Hayfield Road is now just as concerned with pointing out local tourist attractions as with giving directions to nearby towns.

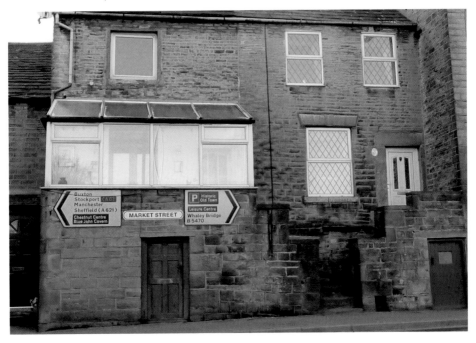

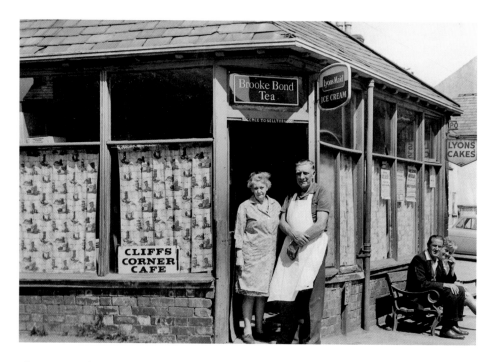

The Corner Shop

For many years, the building at the corner of Hayfield Road West and Market Street was occupied by Cliff's Corner Café, which was valued as a great source of fish and chips. Eventually, the Foster family, who ran a greengrocery business in the other half of the building, expanded into the corner café and converted their business into a popular flower shop. Recently, fruit and vegetables have made a re-appearance alongside flowers. The murals are by local artist Neil Bennett.

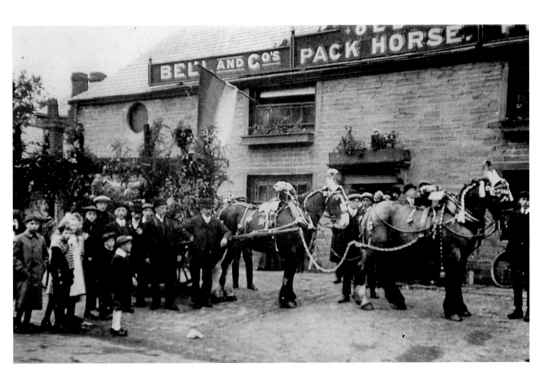

The Old Pack Horse

Although the long, low frontage of the Old Pack Horse at Town End has been extensively remodelled and rendered, the main doorway and adjacent windows remain in their original positions. The present landlord and landlady have also continued the tradition of enlivening the façade of the building with colourful window boxes. The photograph from 1909 shows a float, which carries a Japanese tableau, being prepared for Gala Day.

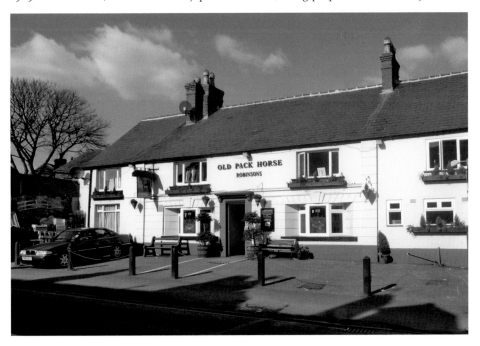

A singularly beautiful building

When Town End Methodist Church was completed in 1874, it was described by the *Buxton Advertiser* as 'a singularly beautiful building'. At the time of its centenary (upper picture), the building was little changed. Twenty years later, a new extension was added to house a coffee bar and meeting room. Describing the alterations, church member Peter Helps said, "The work was carried out so sensitively that the architectural integrity of the original buildings was retained – the imaginative scheme earned a Chapel Amenity Society Gold Award." One result of the modifications was the re-positioning of the main entrance to the church from the front to the side of the building.

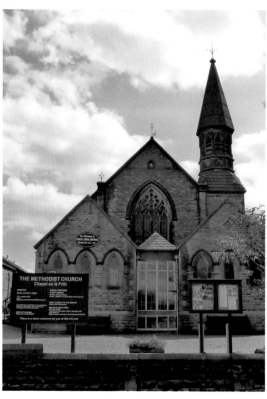

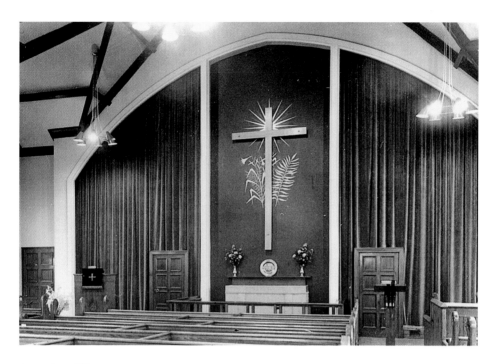

Spot the Difference

At first glance, there seems to be little difference between these photographs of the Methodist Church, but they actually reflect several imaginative changes. One of the curtains masked organ pipes and the other covered an unusable gap, which was also a conduit for draughts. Solid partitions have been installed and two new meeting rooms have been created in the space behind them. The pews have been replaced by removable seating, thereby creating a flexible space for lots of user groups.

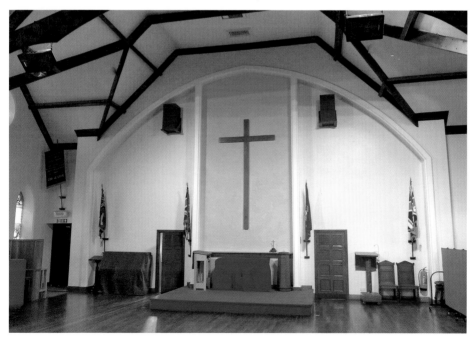

Going for a Song (1)

Chapel-en-le-Frith Male Voice Choir was founded in 1918 by servicemen returning from the Great War. Choir members believe that "singing is the key to a long life", not least because it exercises the lungs. Although the photographs are separated by twenty-one years, many faces are common to the two pictures. However, several new members have joined the ranks in the last few years. A recent performance at the Albert Hall, alongside sixty-six other choirs, raised £150,000 for Cancer Research UK.

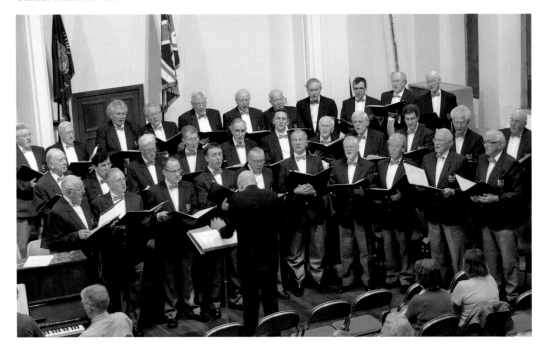

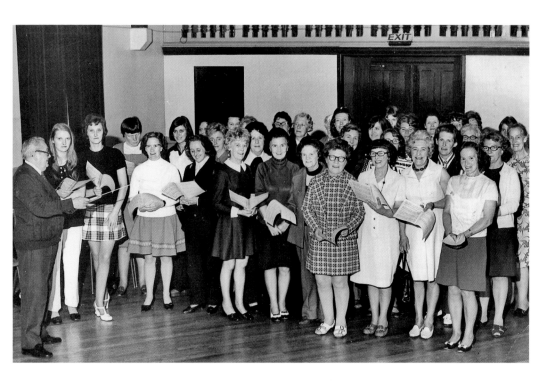

Going for a Song (2)

The upper photograph depicts Chapel-en-le-Frith Ladies' Choir in 1974, the year in which it was formed by shopkeeper Eva Salt and publican and bandsman Ray Holden. The lower photograph shows members of the choir during a performance in the Painted Hall at Chatsworth. They are fronted by musical director Lucy Crew, who succeeded long-term director Norma Clough, accompanist Alison Wheeldon, who was discovered by Norma when she was playing in a school concert, and the choir's president Cllr Ann Young.

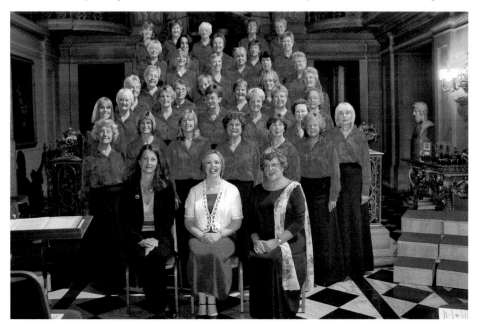

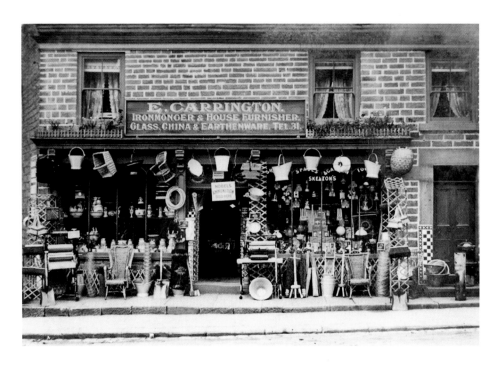

Displaying their Wares

When Edward Carrington opened his Town End shop in 1905, he began a tradition of displaying goods on the forecourt, a habit continued by succeeding family members, who maintained the shop as a family business until 1988, when Joyce and Harry Hall took over the store, which now trades as Hall's Mica Hardware. As well as continuing the tradition of daily forecourt display, Harry and Joyce have shown great enterprise in maintaining the shop as an enormously successful business.

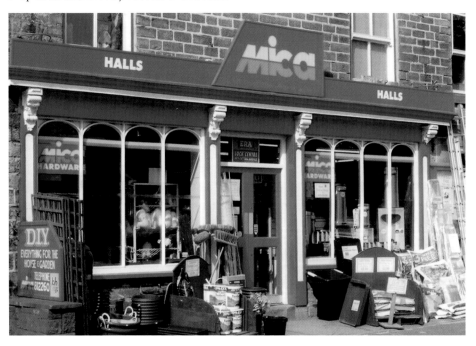

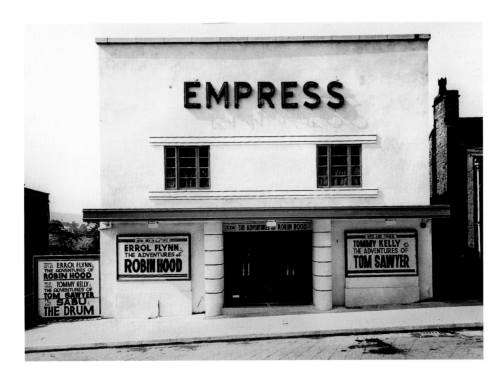

The Last Picture Show

The Empress Cinema, which opened in 1924, was managed by Eldred and Eva Fletcher, who lived with their daughter Beryl directly above the auditorium and even had their own garden at the back of the building. Films were shown here until 1961, when they were replaced by bingo. Ten years later, the building was demolished, together with two adjacent cottages, to make way for the new Shoulder of Mutton. The pub's car park occupies the site of the previous pub.

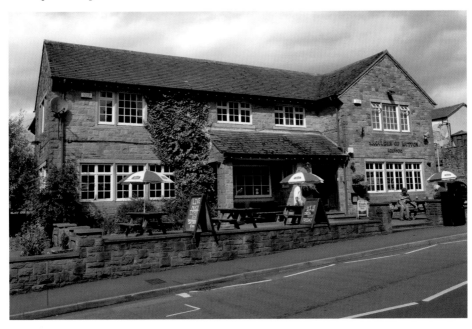

Education, Education, Education (1)

In 1839, a Church of England all-age school was established in this gabled building on High Street. There was also a Methodist school at Town End. In 1947, all primary-age children were moved to Town End. Five years later, secondary pupils were relocated to a new school on Long Lane. Education for infants continued in the High Street building and in several HORSA huts on the opposite side of the road. Infants are shown performing a nativity play in 1971.

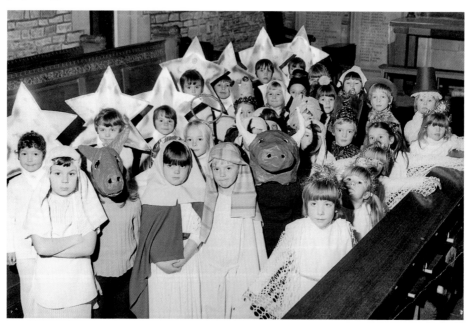

Education, Education, Education (2)

Sandwiched between a railway embankment and the main road, the HORSA huts were shaken a dozen times per day by the vibration from passing trains. They were finally demolished in 1999, when a state-of-the-art infants' school was erected next to Warmbrook Junior School. In 2001, the two schools combined to form Chapel-en-le-Frith C of E (VC) Primary School. The lower photograph shows Key Stage 1 pupils dressed for a nativity play in 2009.

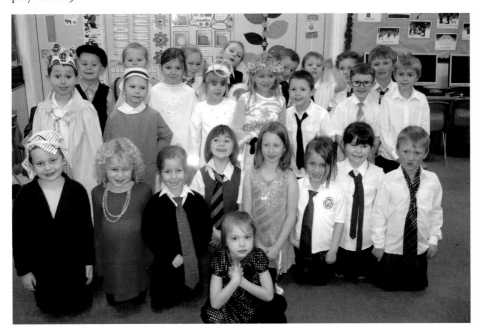

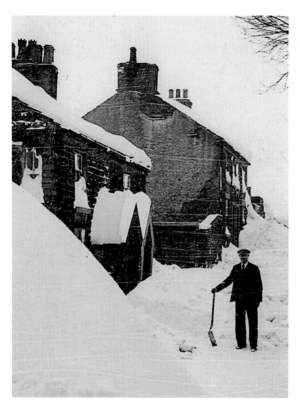

Park Road (1)

This section of Park Road is without a tarmac surface to this day. It is now blocked off to through-traffic by bollards at the entrance from Market Street, but it was completely impassable in the harsh winter of 1947, when there were persistent heavy snowfalls. The gabled porches that were added to two of the cottages many years ago have remained in place to the present time.

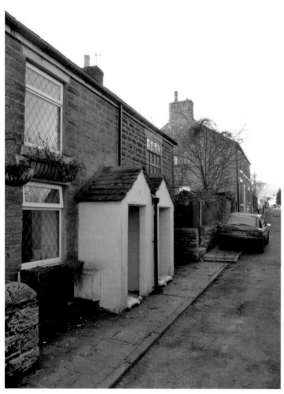

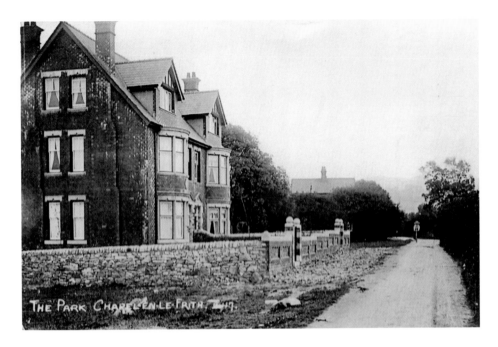

Park Road (2)

When the upper photograph was taken, most of this area was farmland, apart from a few large red-brick villas on Park Road and a tennis court belonging to the Ferodo company. The road is now surfaced and some newer private houses have been built alongside the red-brick villas. After the Second World War, construction began on an estate of local authority housing, which sprang up in the area around Park Road and was then extended to Thornbrook Road.

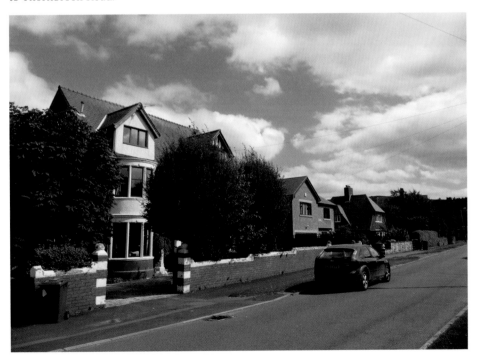

A Field Day for Shoppers

Shoppers had a field day when a large new supermarket opened in 1998. Although its construction on this site had the effect of keeping shoppers in the town, the creation of the supermarket car park and the building of the adjacent Danesway and Hayfield Park housing estates brought about the final obliteration of the fields that once stretched from the parish church to Hayfield Road. The supermarket began life as Safeway, but is now owned by the Morrison chain.

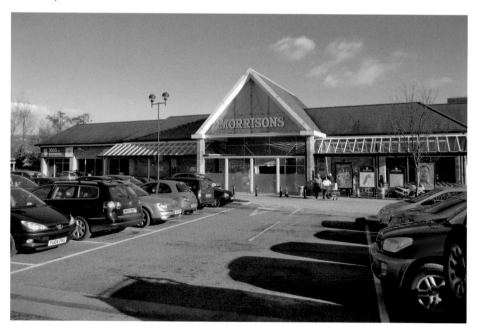

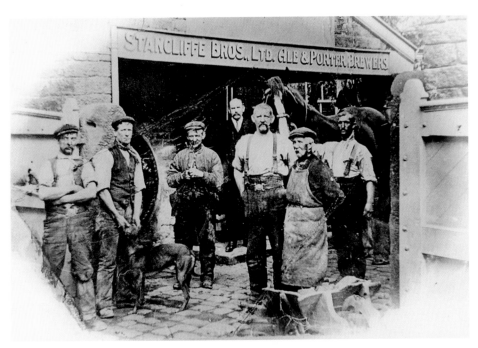

What's Brewing?

Before the First World War, a small brewery was managed by Sam Simpson, who lived in a splendid house in Market Street, at the front of his brewery. The business was sold by the Simpson family to Stancliffe Brothers of Macclesfield and, in later years, the façade of Sam's house was covered by a false frontage. When the building was converted into a group of apartments, the false front was removed to reveal this superb doorway.

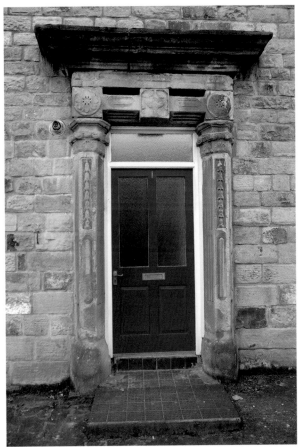

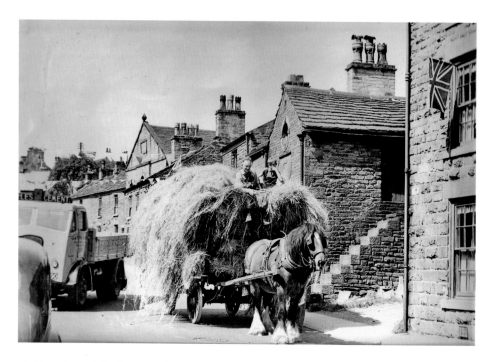

Making Hay while the Sun Shines

According to the late Ada Hitchens, the upper photograph shows the last horse-drawn hay load to pass through the streets of Chapel-en-le-Frith. Tom Longson and his nephew Colin are perched on top of the hay cart, whose slow progress is causing some traffic problems on Market Street. However, as the lower photograph shows, modern agricultural vehicles can cause just as many traffic hold-ups.

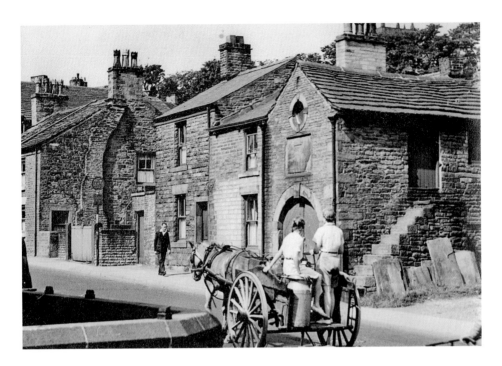

Drinka Pinta Milka Day

George Taylor used a horse-drawn milk float to make daily deliveries of milk to households, but Mr and Mrs Hibbert of Gisborne Dairy acquired an early electric milk float, which carried the slogan "silent efficiency". The Hibberts, who are seen here with their driver Stan Ravenscroft, began business in 1948 with deliveries of 18 gallons of milk. By the time they sold their business to Express Dairies, they were dealing with 3,000 gallons. Mrs Hibbert is now ninety-five years old.

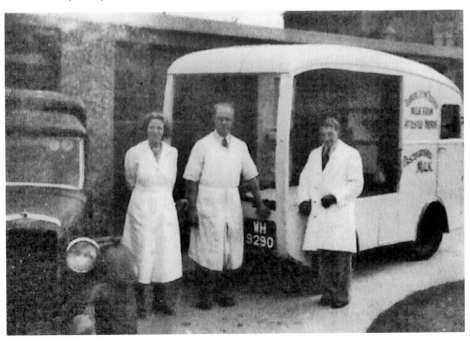

What Might have Been Construction of the Town Hall, originally conceived as a new home for the Magistrates' Court, began in 1850 at the expense of Dr John Slacke of Bowden Hall. In 1947, the town's HM Forces and Welcome Home Fund came up with a proposal to convert the building into a War Memorial Hall. Three plans were presented to the public, including the complete re-build shown below. In fact, no alterations were carried out until 1970, when a first-floor annexe was added.

Putting on an Exhibition

As the 1979 picture of Mr B. Evans shows, art exhibitions have been mounted from time to time in both the Town Hall and the ground-floor Library. However, there is now a permanent exhibition of paintings by Neil Bennett on the stairway leading to the upper rooms. The collection comprises eleven depictions of the town and its surrounding villages. Neil is seen here with Parish Council chairman Stewart Young. The annexe contains several fine paintings by Norman Phillips.

The Parish Pump

An Act of Parliament of 1894 established parish councils with an income funded initially by rates from agricultural land and then from rates levied on householders. In 1994, Chapel Parish Council's chairman, Cllr Ann Young, cut a cake to celebrate the centenary. Cllr Muriel Bradbury, in the centre of the picture, was awarded an MBE in 1995. The lower picture shows the present parish council, with Parish Chaplain Rev. Derrick Leach, Community Police Officer Julie Shaw and Clerk Sue Stockdale.

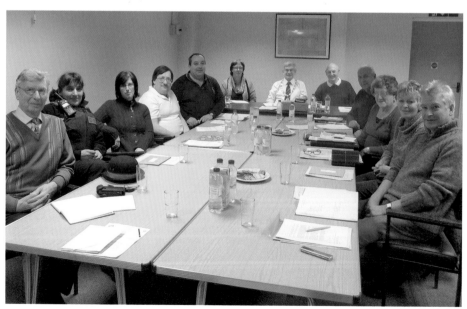

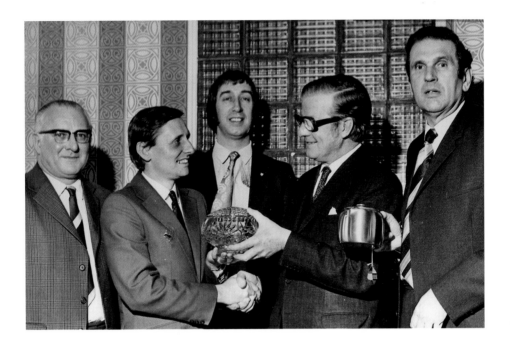

Giving and Receiving

When Rural District Councils (RDCs) were discontinued in 1974, deputy clerk Peter Harrison made a presentation to clerk Raymond Croft. Also pictured are (L to R): rating officer Jack Broomhead; deputy treasurer Graham Sisson and treasurer Jack Lawford. Thirty-four years later, Cllr Peter Harrison was presented with the award of Honorary Townsman by Derbyshire's Deputy Lieutenant Robert Robinson and Parish Council chairman Cllr Guy Martin. Cllr Ann Young had received the same honour in 2004.

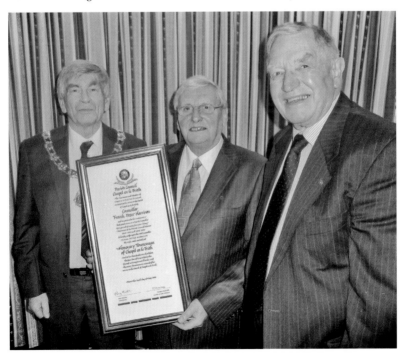

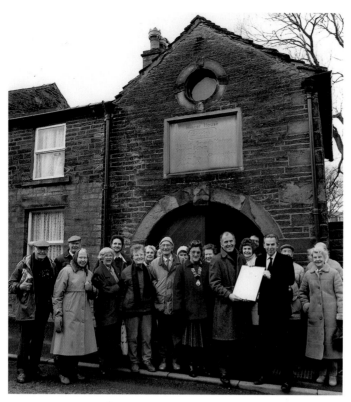

From Hearse to Heritage
The Hearse House was built in 1811 to house the parish hearse. In 1992, it was renovated and converted into a visitor and heritage centre by the town's Amenity Society (now Civic Society), with the help of architect John Bishop (in the grey overcoat). The centre, which now has an information touch screen in its window, stands in Market Street. As the lower photograph shows, the street has colourful displays of flowers in hanging baskets and street planters.

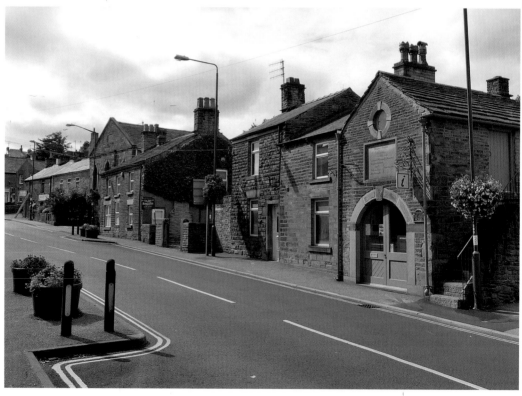

Well Dressed

The ancient custom of well dressing is carried out in towns and villages throughout Derbyshire. In 1995, it was launched as an annual activity in Chapel by the Amenity Society (now Civic Society), which produced this quadripartite picture for the forecourt of the Town Hall. Five wells are now dressed annually by different teams. The picture of Einstein at the Bear Well was created by the Danson family on the 100th anniversary of the publication of the Theory of Relativity.

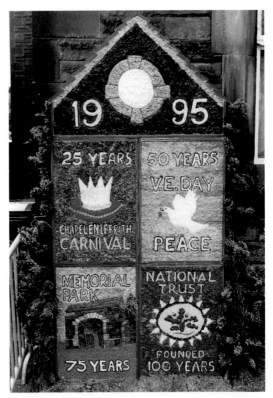

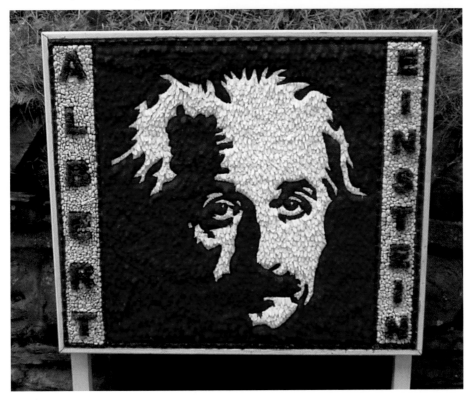

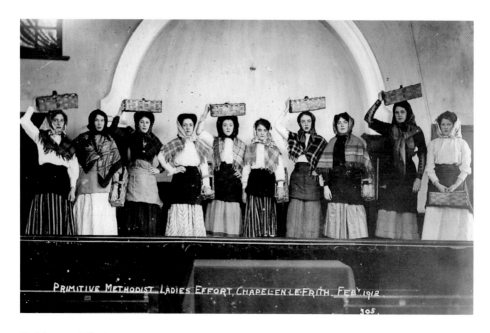

PRIMITIVE METHODIST LADIES EFFORT, CHAPEL-EN-LE-FRITH, FEBY 1912

Making an Effort

Primitive Methodism began in Burslem as a breakaway movement from the Methodists.
It had a good following in Chapel-en-le-Frith, where a Primitive Methodist Bethel was built
in 1852. The chapel has been used for many years as a joiner's workshop by John Kelly, who
has made commendable efforts to preserve the integrity of the building. Half the ladies in
the effort of 1912 were able to demonstrate their ability to balance a basket on their head!

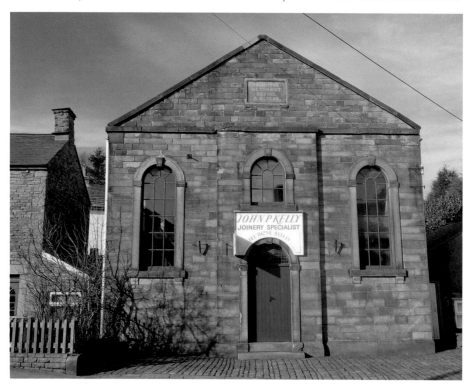

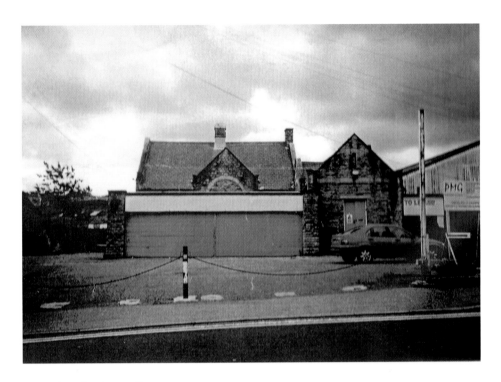

Removing the Camouflage

The Primitive Methodist Sunday School was constructed in 1910. Its façade was completely masked by a garage during the many years when the former school buildings were used by a supplier of tyres for cars and heavy goods vehicles. A recent conversion of the school rooms into apartments has seen the removal of this ugly camouflage and the sensitive restoration of the frontage.

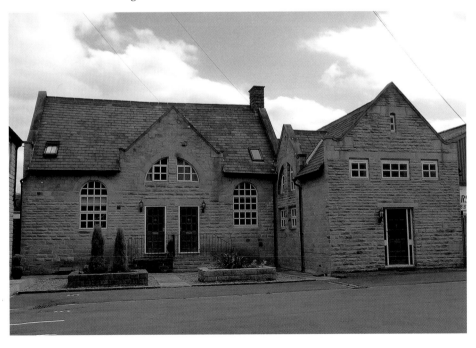

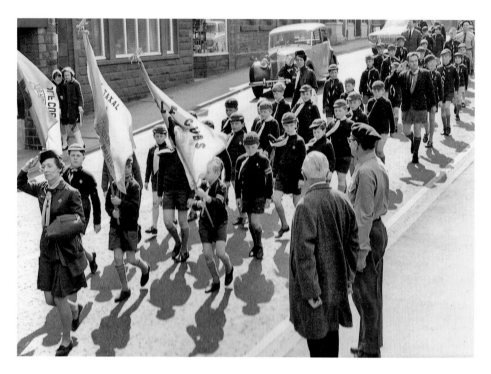

On the March (1)

These illustrations of marches along Market Street show a procession of Scouts and Cubs on St George's Day in 1968 and a parade of Boys' and Girls' Brigades on a recent Remembrance Sunday. The first recorded meeting of Chapel Scouts took place in 1909, when Rev Stredder led a party of Scouts up Eccles Pike. The 1st Chapel Boys' Brigade was founded at Town End Methodists in 1926 and a Girls' Life Brigade troop was formed two years later.

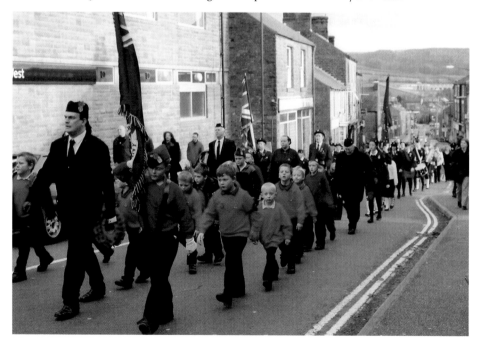

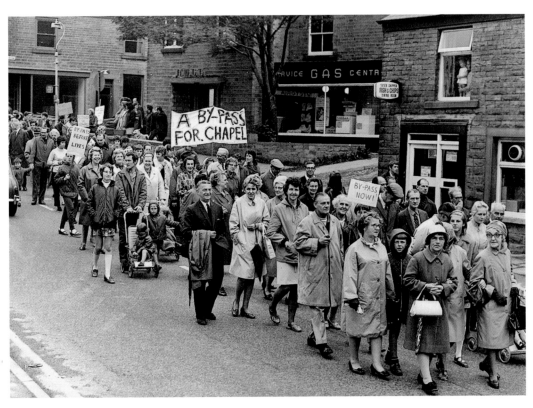

On the March (2)

Until 1987, High Street and Market Street had horrendous levels of traffic, because they formed part of the A6. Fearing for their safety, local people lobbied and marched through the town, in the hope that a road could be built along the Blackbrook Valley in order to bypass Chapel-en-le-Frith. When the road finally materialised, there was much rejoicing, with children and adults taking part in various fun activities on the new road before it was opened to traffic.

The Victoria Cafe and Temperance Hotel,

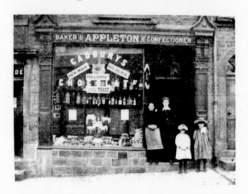

MARKET STREET, CHAPEL-EN-LE-FRITH.

Comfortable Beds, always aired, at reasonable charges.

Every accommodation for Cyclists, Visitors and Commercials. . . .

Proprietor - GEORGE APPLETON.

Changing Tastes

The food and drink served at George Appleton's hotel and café on Market Street included toast, coffee, tea and soda, but strictly no alcohol! The fact that the same premises are now occupied by Al-Amin's Indian take-away reflects a marked change in eating habits. Although the façade of this building has been altered, the frontages of the neighbouring premises are little changed.

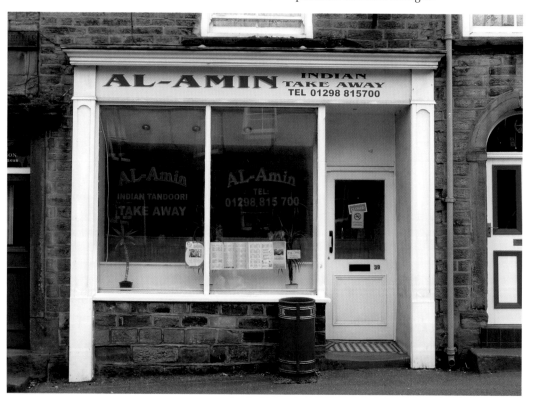

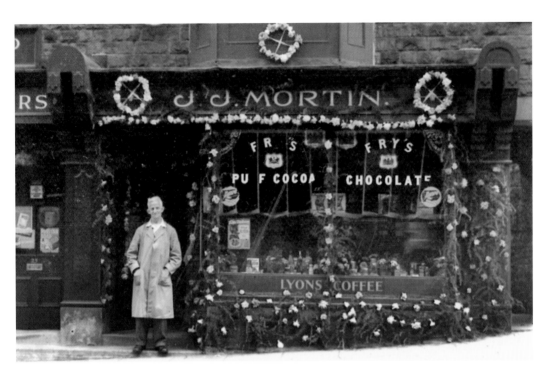

Up Front

Mortin's, seen here decorated for Carnival Day, was a fixture on Market Street for many years. The shop had a rather elaborate frontage, which was completely re-fashioned in a much plainer style when Ken Oates acquired the premises as a gentlemen's outfitters. The shop is currently up for sale. Readers will be able to spot the author reflecting the changes with his camera.

All Traffic Stopped

All traffic was diverted from Market Street on this day in 1970 when a lorry crashed and ended up across the carriageway. Traffic on the same stretch of road is always stopped for the duration of the annual carnival procession, which includes bands, floats, majorettes, people in fancy dress, vintage vehicles and many carnival queens from surrounding villages, as well as Chapel's carnival queen and her retinue.

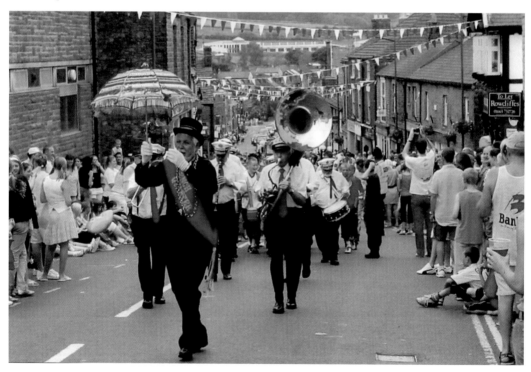

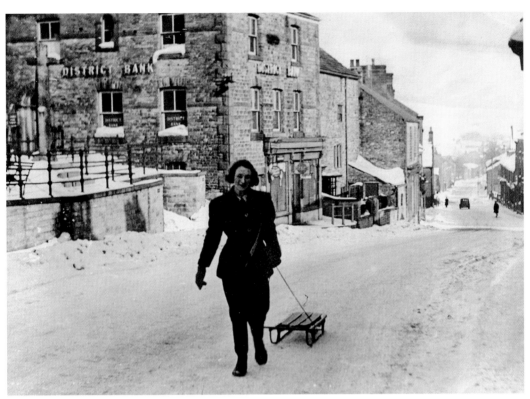

Ladies on the Move

When snow was on the ground during the severe winter of 1947-48, Ada Hitchens could be seen pulling a sledge up Market Street. Elaine Symmons caught the attention of the crowd, and hopefully some money in her collection box, when she walked up Market Street in fancy dress on a Carnival Day during the 1970s. Prizes are always given on Carnival Day for best fancy dress and the best-decorated floats, pubs, shops, houses and lamp-posts.

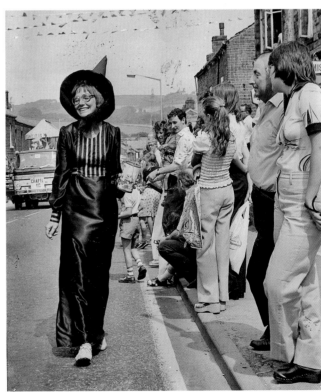

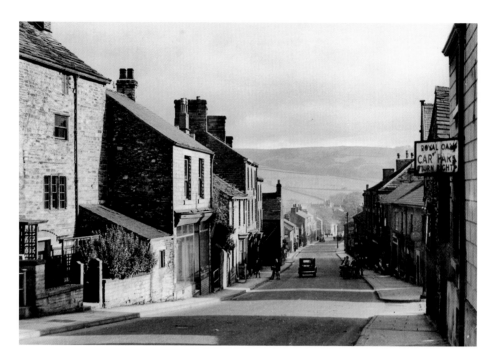

Looking down Market Street

Although the fine house that is prominent in the foreground of the older photograph has been replaced, the contours of this section of Market Street have remained largely intact for the past sixty years. However, there are some important detail changes: aggregate has replaced stone flags on the pavements; road markings and parking bays have been introduced; brighter street lighting has been installed; 'pregnant pavements' have been introduced as a traffic-calming measure and street planters have appeared.

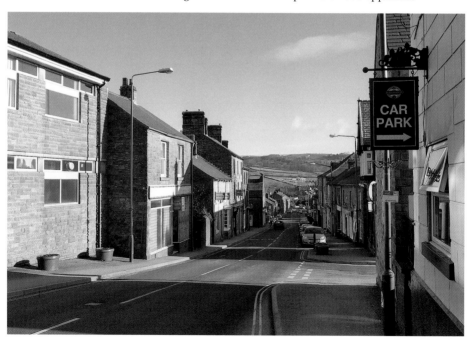

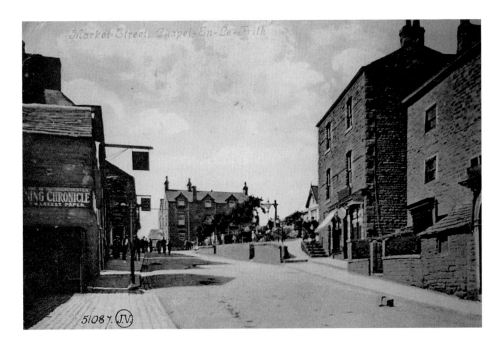

Looking up Market Street

A clockwise sweep around these photographs reveals several changes. The building with the advertisement was demolished after falling into decay, but the unsightly gap in the streetscape has now been filled. The road has been widened; the King's Arms has acquired a white coat and the gabled 'White House' beyond it has gone; the large lamp standard has also gone, but a war memorial has appeared; and the tall bank building has been replaced by a long, low 'modern' bank.

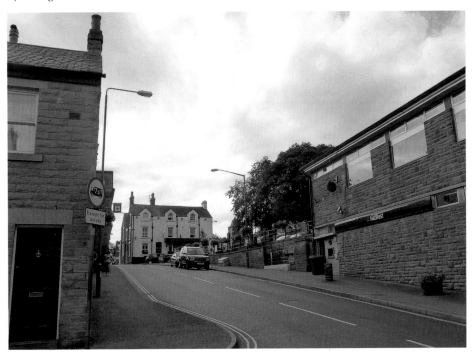

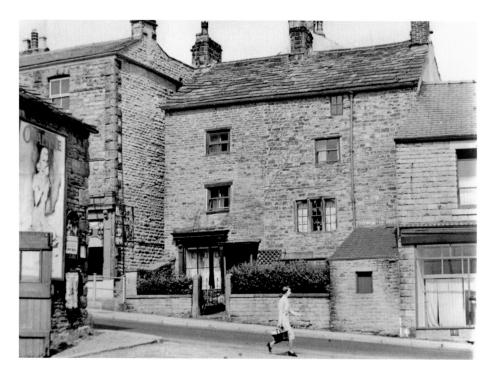

New for Old

The fine house facing Rowton Grange Road was known as Miss Goddard's house. It has made way for the NatWest Bank building, which has wall and roof materials appropriate for the locality, but a style that is foreign to the district. The advertisement-festooned building on the corner of Rowton Grange Road was used as a garage. Its demolition left an unsightly gap, which has now been filled by a new-build in an appropriate local style.

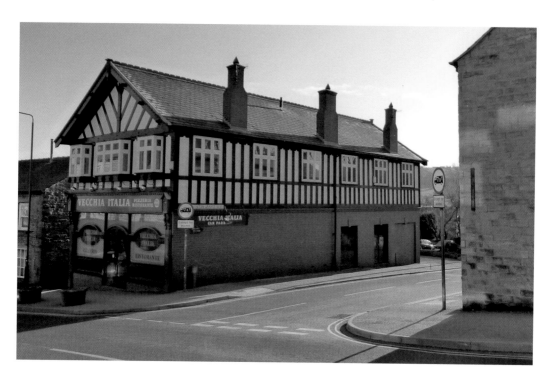

Old Italy

For the last two decades, the Vecchia Italia, on the corner of Rowton Grange Road, has been a very popular Italian restaurant, not least because restaurateur Giovanni has the knack of making all his diners feel very special. The mock half-timbered building was formerly occupied by Seymour Meads, a well-stocked general store. As the struggling horse illustrates, Market Street rises quite steeply as it makes its final approach to the Market Place.

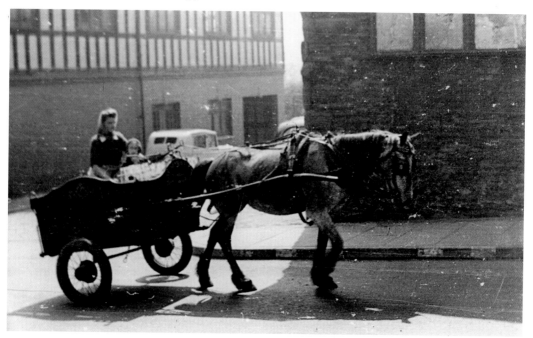

Remembrance and Mementoes

Although plans put forward by the HM Forces and Welcome Home Fund for a new Memorial Hall never came to fruition, their proposal for a Memorial Arch at the entrance to the Memorial Park was realised in 1953. The time capsule placed under the arch by Parish Council Clerk George Ainscow contained a set of new coins, a Roman coin, copies of two local newspapers, plans for the arch and a list of members of the Welcome Home Fund.

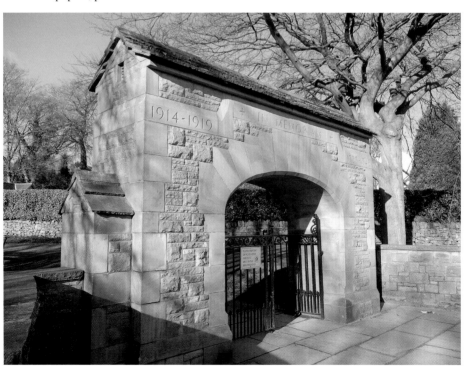

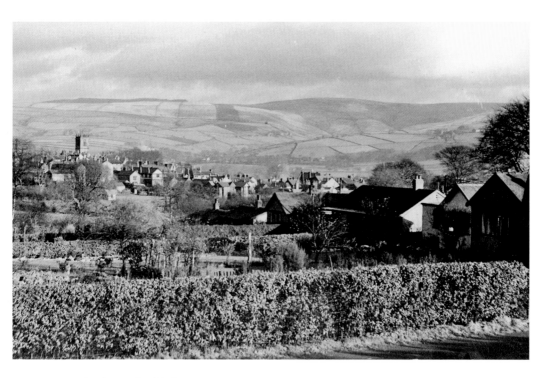

A Town in the Peak District

From the Horderns Park Road area, there are superb views of the old town of Chapel-en-le-Frith and its ancient church set against a backcloth of Peak District hills. The top of the church tower is almost 800ft above sea-level, but the surrounding hills of the Dark Peak rise to an altitude of over 2,000ft on the summit of the Kinder Scout plateau.

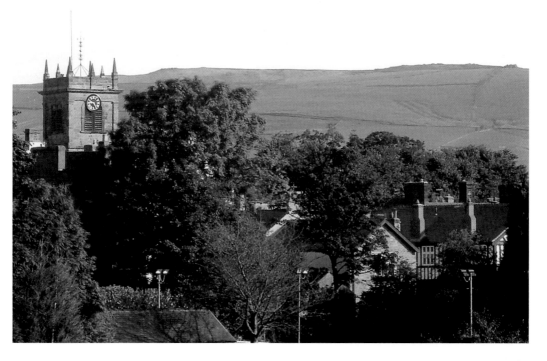

Like Mother, like Daughters

Chapel Carnival has its origins in Hospital Gala Days, which were held in the early years of the twentieth century. During the 1930s, the carnival procession ended in the football field on Park Road, where Commander Cook acted as Master of Ceremonies. After a lapse of some years, the carnival was revived as an annual event in 1970. These days, the procession proceeds through the town to the Memorial Park, where the Carnival Queen is crowned and lots of other festivities take place. Jeanette Cohen (now Saxby), pictured above, was crowned Carnival Queen in 1978 and Queen of the Peak one year later. Exactly thirty years on, her daughter Rachel Saxby (below left) became Chapel Carnival Queen and was crowned as Queen of the Peak in the following year. To complete the family tradition, Rachel's sister Cathryn Saxby (below right) became Chapel Carnival Queen in 2009.

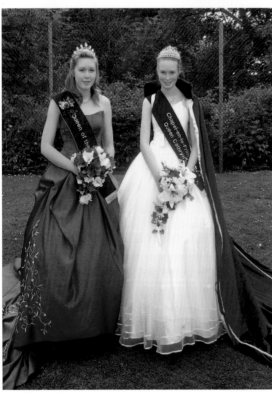

The Band Played On

According to its president, Bob Mulholland, Chapel Town Band was formed in 1882 by a group of brass players who had provided music in the parish church until a new organ could be installed. The photograph of the band from the 1970s includes Derek Tideswell, Lesley Anderson and John Bramwell. Chapel's band achieved championship status in the 1940s and flourished again in the 1980s. After a period of decline, it has undergone a revival in recent years under the direction of Aidan Howgate, not least in attracting and training young brass players. The biennial Proms in the Park (lower photograph), initiated by Bob Mulholland, has proved to be a highly successful event in the Memorial Park.

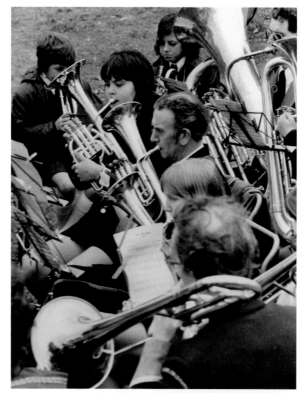

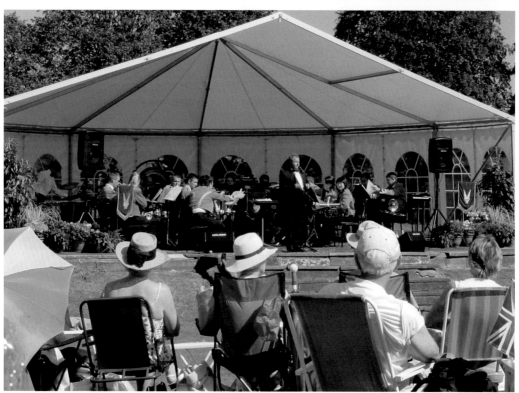

All the World's a Stage

Chapel Payers was formed in 1927, when the Male Voice Choir broke away from an operatic and dramatic society established by ex-servicemen. Since 1952, the Players have been based in the former Constitutional Hall, which they now own. Over the years, they have put on some 250 plays, including the 1948 production of *See How they Run* (above), described as 'outstanding' in the local press. Annual pantomimes, such as *Cinderella* (below), have been part of their repertoire since 1978.

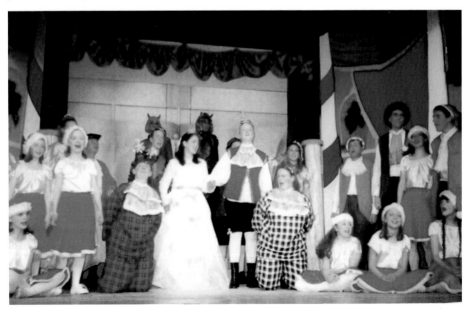

Watch the Birdie

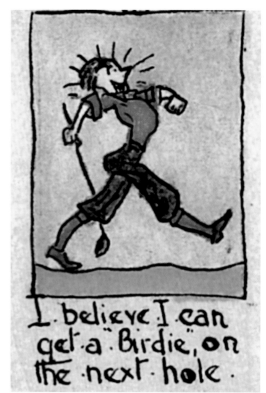

Described by *County Golfer* as having 'one of the most picturesque courses in the North Midlands', Chapel Golf Club was formed in 1905 by several members of the local gentry, including Mr Ritchie of Bowden Hall and Gaston le Peton of Combs, whose daughter, Peggy Bellhouse, drew the cartoon as part of a 'birthday card' sent to the club. Professional Len Saunders, who was with the club for 37 years, designed a new 9-hole course in 1919, and the course was expanded to 18-holes in 1972. A superb new clubhouse (below) was opened in 1995. Its balcony provides a fabulous panoramic view of the course and the surrounding hills of the High Peak. The club's best known professional was Leo Feeney, who was tragically killed in a traffic accident in 1977.

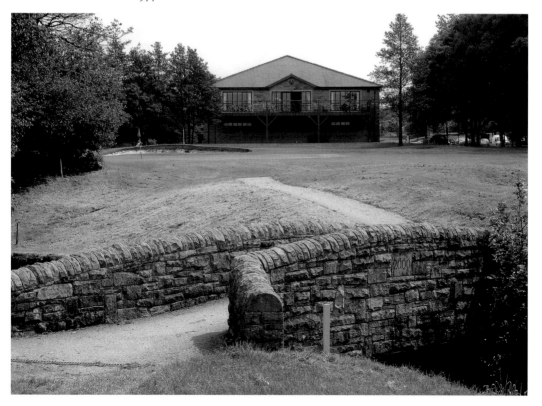

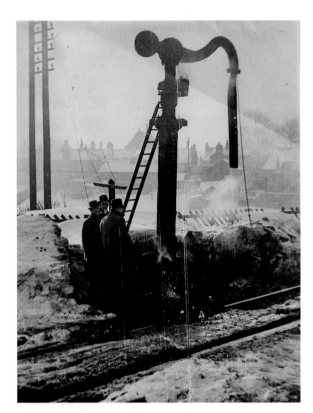

Off the Rails

Chapel's Central Station was opened for goods traffic in 1866 and for passenger trains one year later. The prominent brackets on the eaves of the station building are similar to those on other stations built by the Midland Railway at Rowsley, Bakewell and Glossop. As a result of cuts proposed by Dr Beeching, the station was closed in 1967, leaving the town with Chapel South station, which stands at some distance from the centre. The former Central Station buildings, which are now occupied by Chapel DIY, retain their highly distinctive eaves.

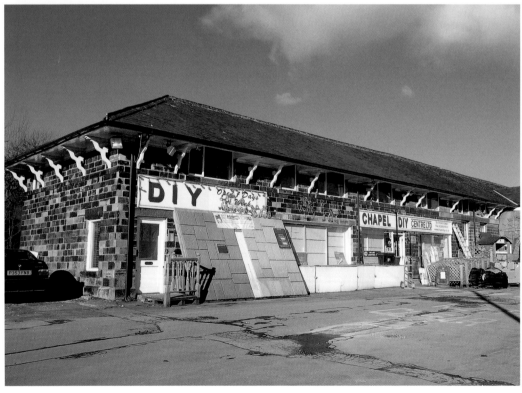

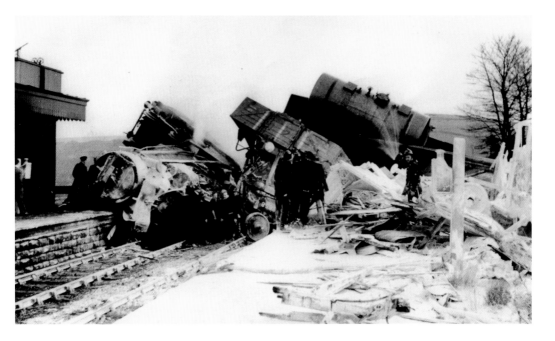

The Runaway Train

On 9 February 1957, a brake pipe broke on a goods train travelling from Buxton. Driver John Axon told his fireman to jump clear and apply as many wheel brakes as possible. Although Axon could have jumped clear at this stage, he stayed in his cab and tried to bring his locomotive under control as it gathered speed down a 7-mile incline. Thanks to warnings he waved to signalmen, staff at Chapel South were alerted and managed to evacuate a passenger train on the up-line, but they were unable to warn the crew of a slow-moving freight train on the down–line. When Axon's train crashed into the moving train, he was killed, together with John Creamer, the guard on the freight train. Axon's bravery was recognised in a radio ballad written by Ewan MacColl and on a plaque erected at Chapel South on the fiftieth anniversary of the crash.

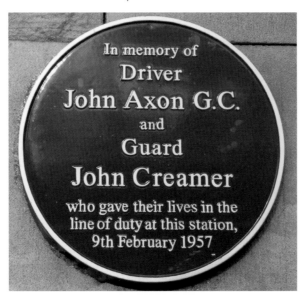

Serving the Community

The building that stands at right angles to High Street is Cromwell House, which is now an area office of Derbyshire County Council's social services department, but was formerly a children's home. This stately building stands on the site of Cromwell Croft, where there was a school, which was founded in 1696 by a bequest from Mary Dixon and was originally sited in the Horderns area.

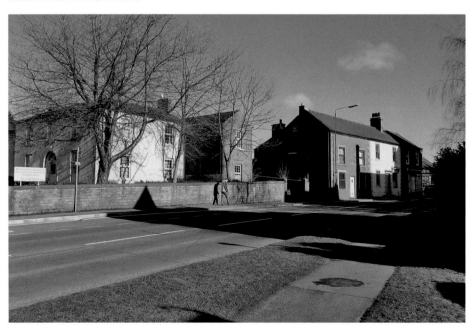

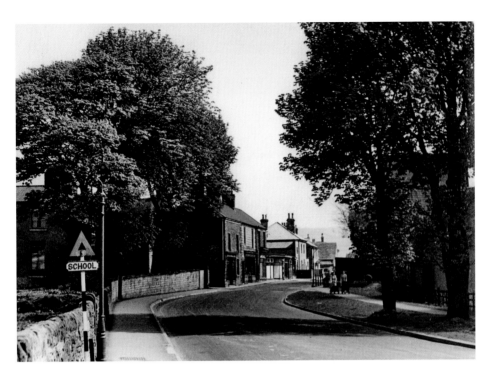

Round the Bend

Although these photographs are clearly depictions of the same stretch of High Street, the road appears to have mysteriously lost its sharp bend in recent years. Closer inspection of the two pictures reveals that the wall in front of Cromwell House has been moved back from the carriageway, in order to create a bus lay-by. Although trees have been lost on the nearside of the road, a new public bench has been provided.

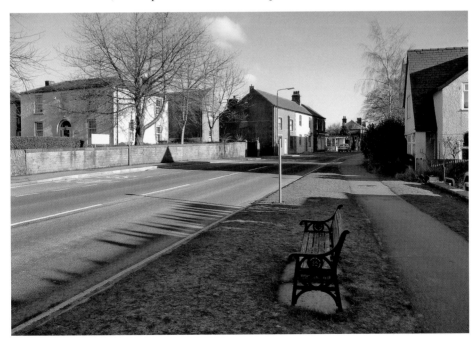

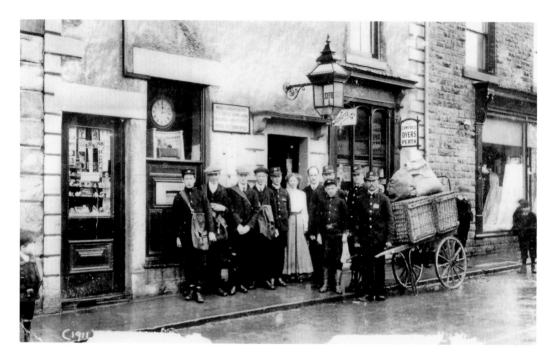

Restoration

For many years, the former post office on High Street was occupied by Douglas Ryder's electrical shop. It is now being converted into a house but, thanks to a grant from the Heritage Economic Regeneration Scheme (HERS), which has been used to restore many traditional frontages in the town, the architectural details of the original building are being carefully restored to create a very attractive façade.

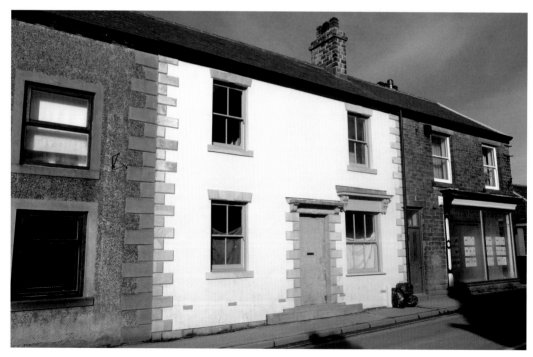

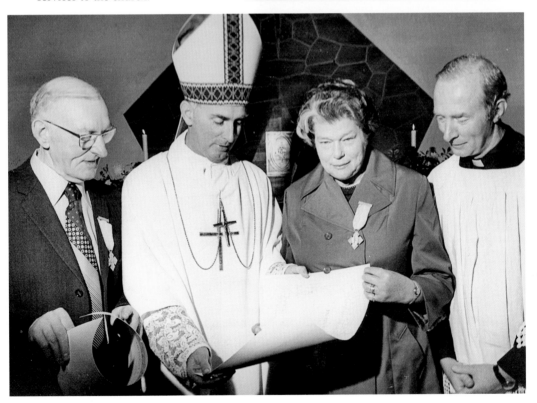

Papal Blessing

Until 1937, Chapel's Roman Catholics had to attend services in Tideswell, because they had no church of their own. The Church of St John Fisher and St Thomas More was constructed on Horderns Road in 1937 with funds provided by several benefactors, including Mr and Mrs Carter, who lived in the Hope Valley and were known for Carter's Little Liver Pills. In 1978, Martin Kelly and Donna Kadzevska (pictured below) received a Papal Medal and citation for their services to the church.

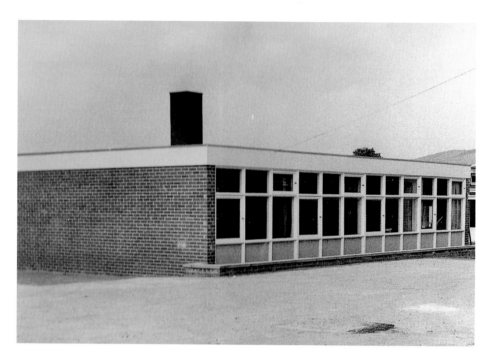

Education for All

Chapel's secondary school opened on Long Lane as a secondary modern school in 1952 and took its first comprehensive intake in 1973. An adult education centre (above) was added in 1970 and a brand-new school was built on the site in 2003, using a Private Funding Initiative (PFI). The people of Chapel had campaigned long and hard for a new leisure centre and this was also provided. It is just visible on the extreme right of the lower photograph.

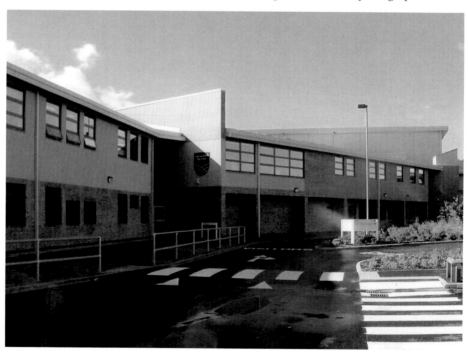

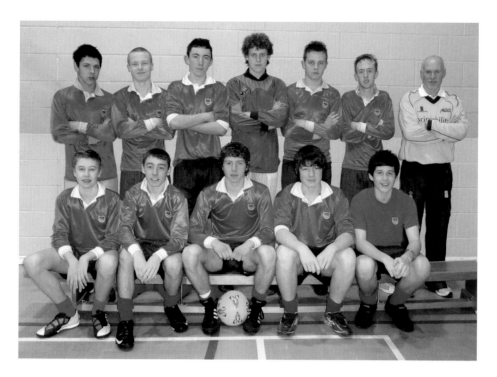

Sport for All

Since 2005, Chapel High School has been a specialist technology college. As the school shares facilities with the adjacent leisure centre, it also has superb provision for sport. The photographs show the school's current under-16 football team (above) and the team from 1968 (below), when Dan Northall the original headteacher, was still at the helm. Mr Northall died recently, aged ninety-four. The current headteacher is Stuart Ash, who steered the school through the very lengthy PFI negotiations.

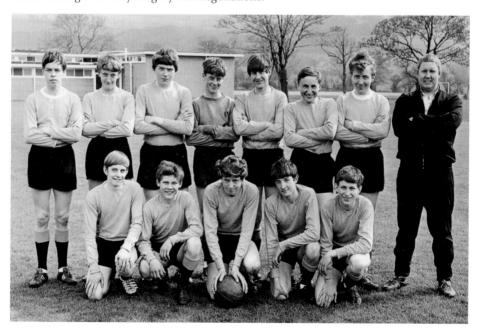

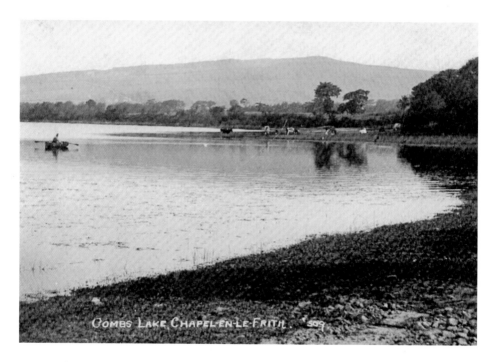

COMBS LAKE CHAPEL-EN-LE-FRITH. 509.

A Beautiful Sheet of Water

Combs Reservoir was constructed in 1794 to service the Peak Forest Canal, which runs from Buxworth into the Manchester conurbation. In an 1827 directory, the 80-acre lake was described as 'a beautiful sheet of water much frequented by anglers'. Since 1950, it has also been much frequented by sailors who are members or guests of Combs Sailing Club. The lower photograph shows boats steered by Scouts who are being taught to sail by club members.

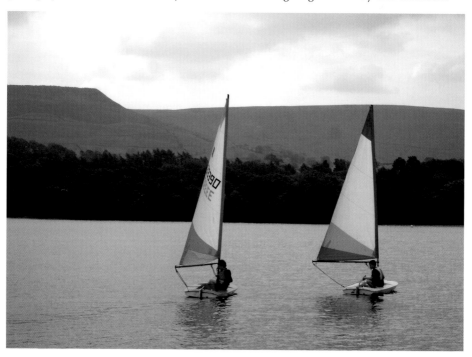

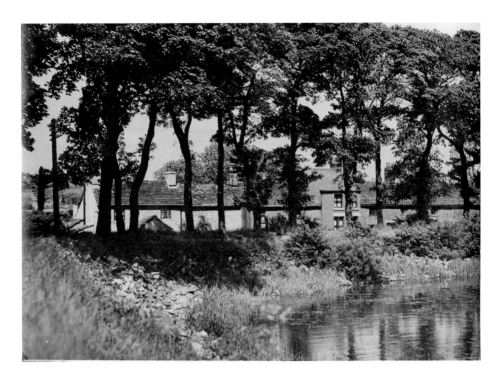

Safety First

During a severe gale in January 1976, the dam wall of Combs reservoir began to slip and urgent action had to be taken to lower the level of water. Although levels were kept low for eight years while major reinforcement work was carried out, members of the sailing club managed to carry on sailing. Construction of a new retaining wall made the reservoir safe, but reduced the beauty of this view of Tom Lane from the edge of the lake.

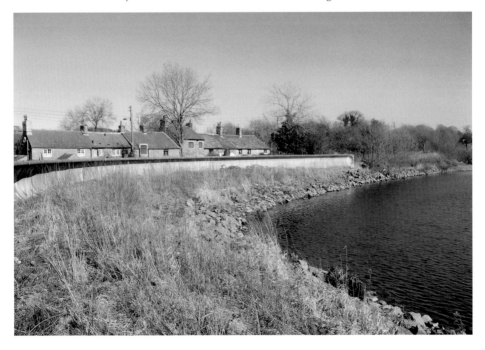

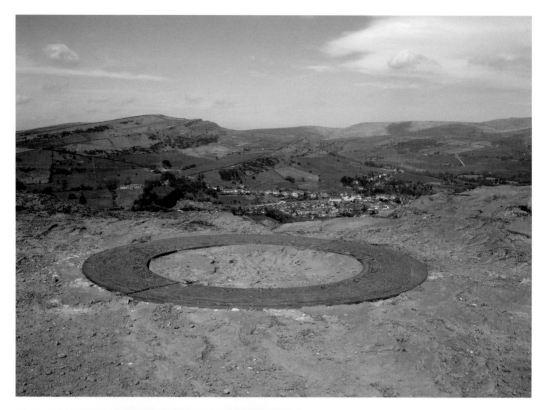

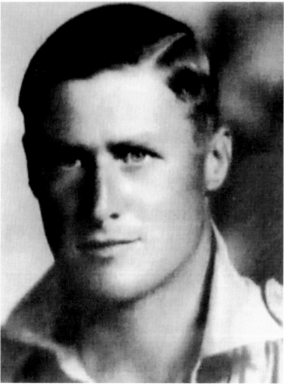

Point of view

Eccles Pike is a conical peak located 1.5 miles west of Chapel-en-le-Frith. In the millennium year, a bronze topograph was placed in the distinctive pink stone at the summit, in order to pin-point all the features visible in the magnificent 360-degree view that can be enjoyed from this spot. In 2009, a plaque was placed just below the summit in memory of Highley Sugden (pictured below during his service days), a great benefactor and supporter of the National Trust, who supplemented Mrs Spencer's substantial gift of land on the Pike by a donation of his own to the National Trust. Until the last few weeks of his long life (he died at the age of 94), Highley could be seen every day, come rain or shine, walking to the summit of Eccles Pike with the aid of his two Nordic walking sticks.

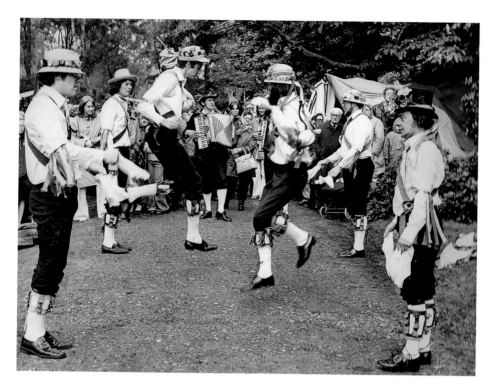

A Spring in their Step

Chapel's Morris side was formed in 1975 by Will Newman and Alan Wilson. The dancers undertake an annual tour of the Peak and appear at various events in this country and abroad. At sunrise on May Day, they perform on the summit of Eccles Pike (below) in a spring fertility ceremony. After they gave a similar performance in a farmer's barren field, no crops grew but a bull escaped and went on the rampage with cows in the next field!

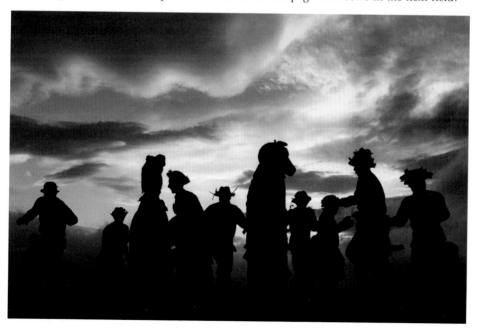

Good for your Health

Nanny's Well on Crossings Road is a medicinal spring that takes its name from a guardian spirit called St Anne or St Ninian (pictured here in a recent well dressing). Although a survey of 1895 reported that the spring water 'is of the same nature as that from the Tunbridge Wells Springs', EU regulations have deemed that it should not be drunk. However, the annual well dressing certainly lifts the spirits of all who visit the well.

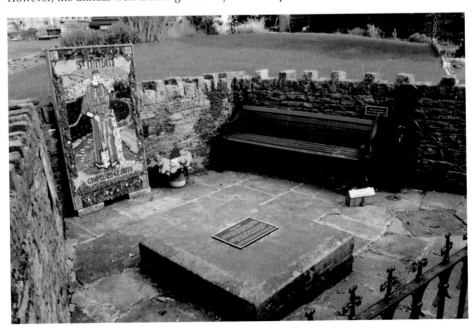

Halls and Hamlets
in the Hills

Tucked into folds in the high gritstone hills that surround Chapel-en-le-Frith, there are several picturesque villages. Exploration of the narrow lanes that criss-cross the hills also reveals a remarkable concentration of country estates and halls. These are said to have their origin in the years of the Royal Forest of the Peak, when 'burgages' were granted to foresters in return for services to the Crown.

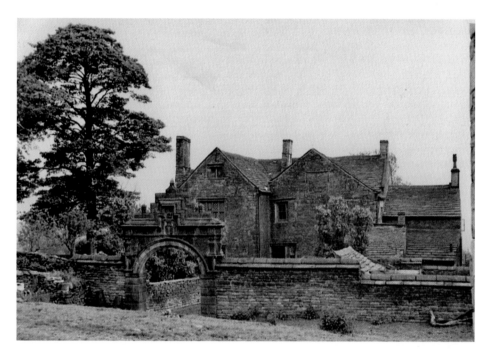

Bradshaw Hall, on the southern slopes of Eccles Pike, was built in 1620. With its transomed and mullioned windows, fine array of gables and cladding of warm brown stone, the hall looks like a sudden vision of the Cotswolds in the heart of Dark Peak hills. The elaborate Jacobean gateway bears the coat-of-arms of Francis Bradshawe, the cousin of Judge John Bradshawe, who presided over the court that condemned King Charles I to death.

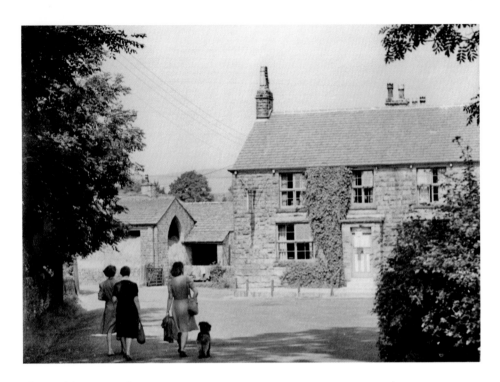

The Beehive at Combs

The pretty village of Combs occupies an idyllic location between the great ridge of Combs Moss and Combs Reservoir. The Beehive Inn was re-built in the 1860s, using money spent at the old inn by construction workers employed in building a new railway line for the London North Western Railway and a new road to Chapel-en-le-Frith. Today, the Beehive is a very popular venue for eating and drinking.

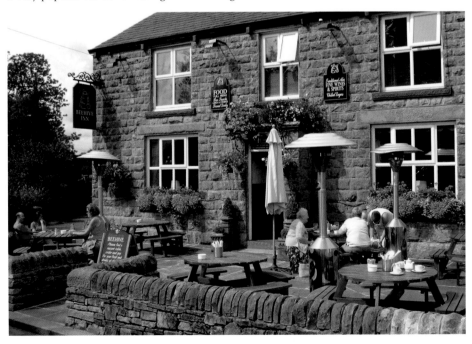

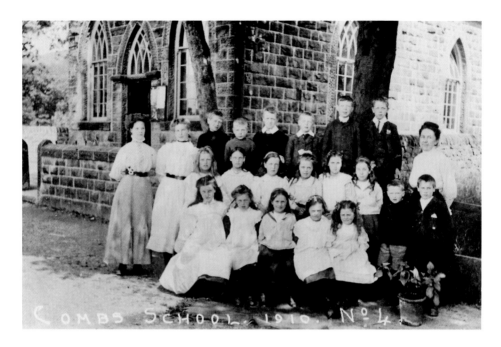

Combs School

Combs School opened in 1881. It was recently saved from closure after a successful campaign by villagers. The school building, which also serves as a Methodist chapel and a village hall, has a modern extension that is linked to the original schoolroom by a glass atrium and is heated by an air-to-air heat pump. The upper photograph shows pupils of the school in 1910 and the lower picture depicts pupils on a visit to the Chestnut Centre in 2008.

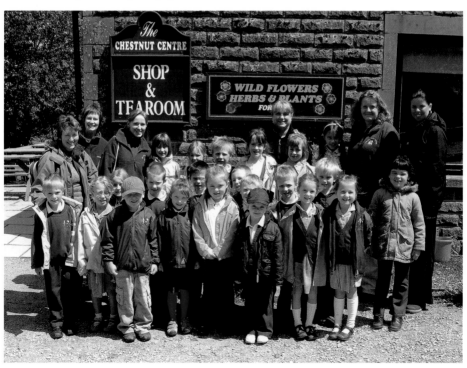

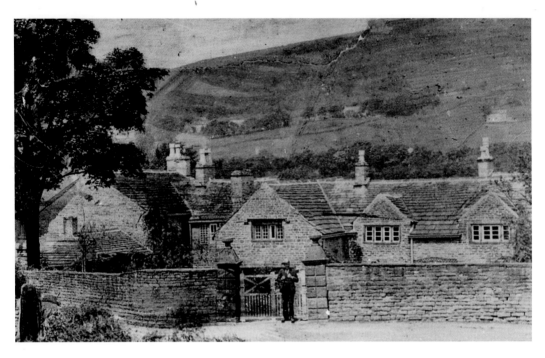

The Old Hall, Whitehough

The hamlet of Whitehough nestles in a cosy valley at the foot of Chinley Churn. According to a date above its doorway, the hall at the centre of the village is a late Elizabethan manor house. This beautiful building has barely changed in appearance over the years. The Old Hall Inn, which adjoins the hall, is a popular drinking and eating place, with a restaurant that opens into the space below the hall's minstrels' gallery.

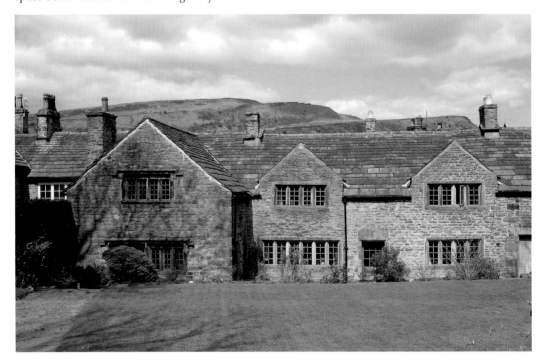

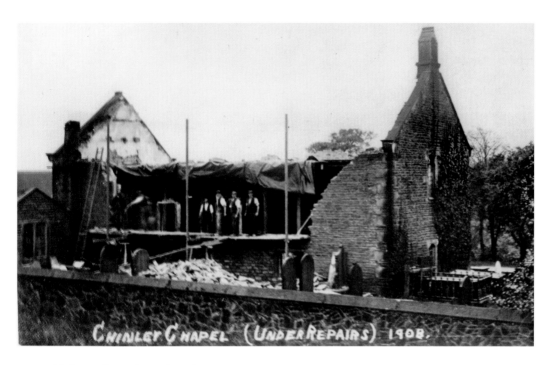

Chinley Independent Chapel

The Independent Chapel at Chapel Milton was built in 1712 as one of the oldest non-conformist churches in the country. Although this charming place of worship has barely changed in appearance in 300 years, it was almost completely dismantled when repair work was carried out in 1908. The chapel is the burial place of Grace Murray, who would have married John Wesley, the founder of Methodism, but for the objections of Wesley's brother Charles.

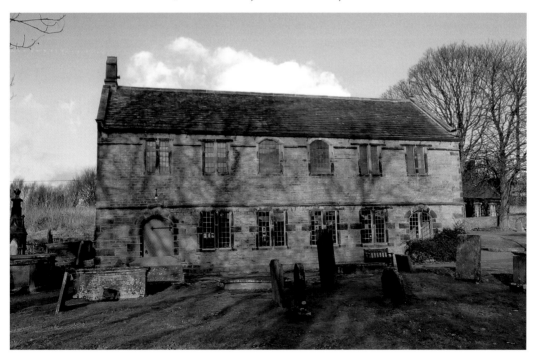

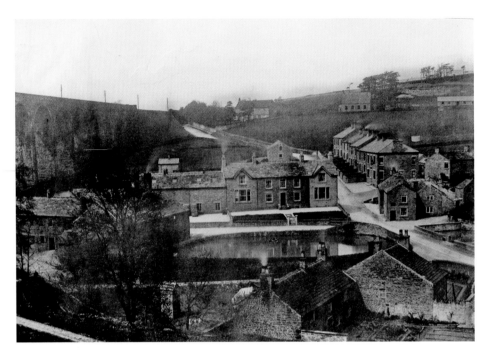

Chapel Milton (1)

The upper photograph was taken before the construction of a second railway viaduct in 1894. The old mill to the left of the double-gabled Milton House was demolished in 1946, and the mill pond has also disappeared. When John Wesley preached here in 1745, the miller tried to drown out his sermon by deliberately releasing a gush of water, but Wesley raised his voice so that it could be heard 'at the very skirts of the congregation'.

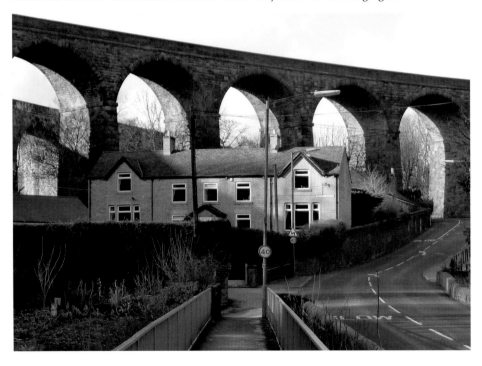

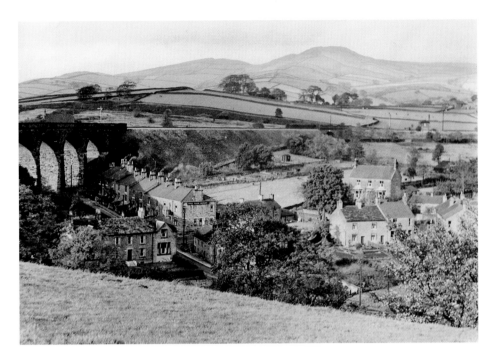

Chapel Milton (2)

Chapel Milton's twin curving viaducts are impressive legacies of the Railway Age. The first one was built in 1866 and the second one, shown in both these photographs, was constructed in 1894. As a comparison of the two illustrations shows, the car park of the Cross Keys Inn covers a plot formerly occupied by a terrace of cottages. The twin peaks in the background of the older picture are Mount Famine and South Head.

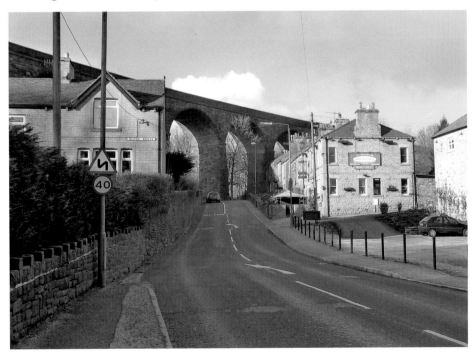

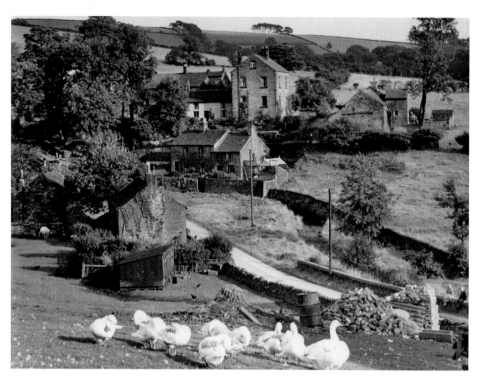

The Wash (1)

Set around a meandering stream in a hollow below South Head, the idyllic little hamlet known as the Wash has changed little in the sixty years that separates these photographs. The prominent building at the summit of the hill was formerly used as a Quaker meeting house.

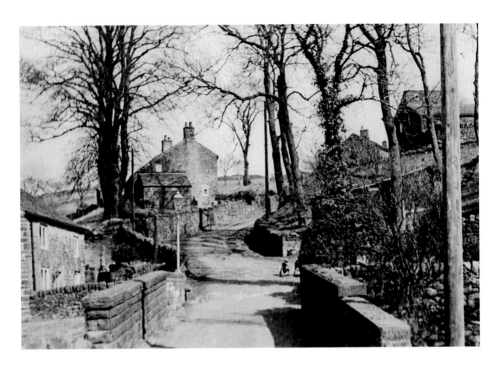

The Wash (2)

These photographs depict the narrow country lane that leads from the Wash to Bowden Head. Since the first photograph was taken, a warning sign for motorists has been installed, a street lamp has been lost and a red telephone box has been added. Despite the recent removal of these iconic telephone boxes from many places throughout the country, this one remains – at least for the present!

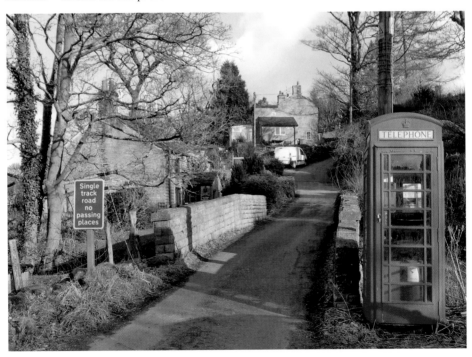

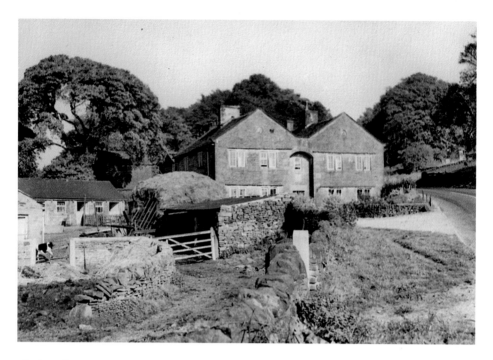

Slack Hall

Slack Hall dates from 1727. When the Sheffield-Chapel-en-le-Frith Turnpike (now Castleton Road) was built and the road was constructed through the garden of the hall, the owners decided to erect a new hall in the valley to the south of the road. However, the old hall remains intact and now has provision for bed and breakfast. The Lingards, who once lived here, were devout Quakers. Several family members are buried in the Quaker burial ground behind the hall.

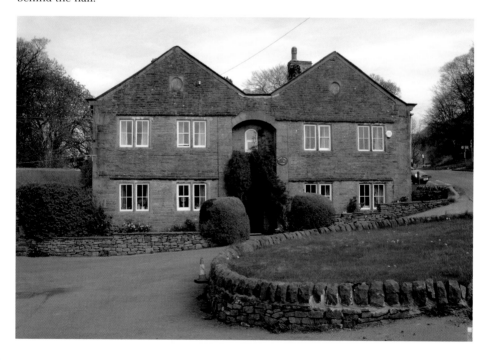

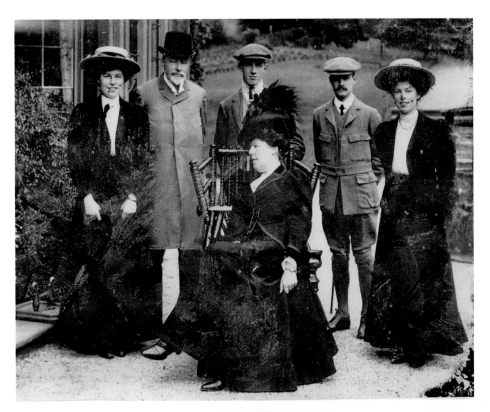

Ford Hall and the Chestnut Centre

Ford Hall, which sits in a deep hollow below Castleton Road, is the ancestral home of the Bagshawe family. William Bagshawe became known as the Apostle of the Peak when he continued to hold secret services in the hall and in many other parts of the Peak after being expelled from his ministry at Glossop in 1690 for refusing to conform to the Book of Common Prayer. The family group includes Frances Alice Deveraux Bagshawe, who is seated in a family heirloom, and Dorothy and Lillian, beautiful twin sisters who were born in 1887. The grounds of the hall are now occupied by the Chestnut Centre, a very popular visitor attraction with a large collection of owls, otters and other animals. Keeper Rebecca Wood is pictured taking a walk with 'Apricot'.

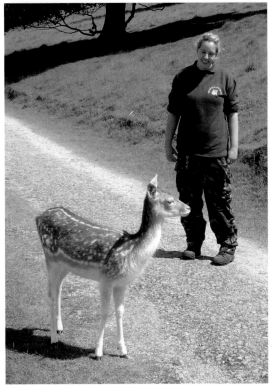

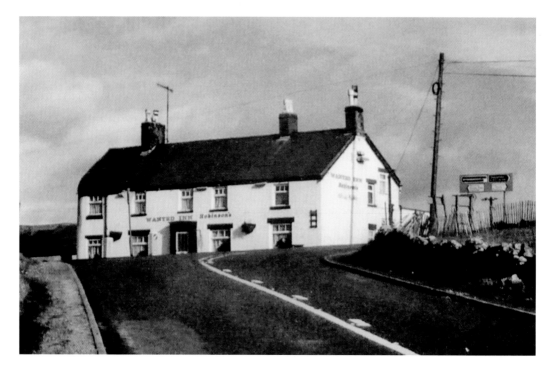

Sign of the Times at the Wanted Inn

The Devonshire Arms at Sparrowpit was renamed the Wanted Inn when it was bought by Mr and Mrs Buswell of Whitehough in 1956 after it had been left empty and 'unwanted' for some time. A welcome sight for travellers, the inn stands some 1,200 feet above sea-level. Unfortunately, the spectacular approach to the building has been spoilt somewhat by the intrusion of a large speed limit sign and two gigantic chevron signs warning of a sharp bend in the road.

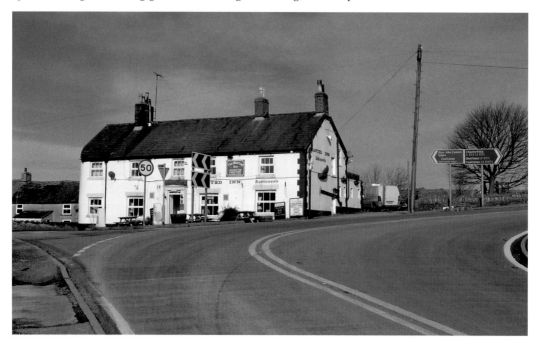

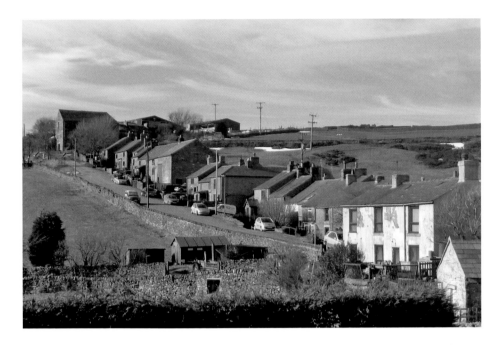

Sparrowpit

The village of Sparrowpit stands on the watershed of England. As the recent photograph shows, it remains a one-street village with almost all its houses confined to one side of the street. The drawing was used as an illustration in the 1936 edition of Humphrey Pakington's *English Villages and Hamlets*, in which he describes the hamlet as 'a mere handful of grey houses, which has a certain picturesqueness as it stands stolidly facing the winds of heaven'.

Acknowledgements

I am especially indebted to: John and Claire Mortin, who allowed me to use the photographs of F. B. Hills and supplied me with a great deal of useful information; John Phillips, editor of the *Buxton Advertiser*, Derbyshire Library Service and the helpful staff of Chapel-en-le-Frith Library, who gave me access to an archive of photographs from the newspaper; Brian Aries, chairman of Chapel Civic Society, who gave me access to photographs in the society's archives; Jane Goldsmith, who donated an archive of photographs by the late Alan Watson; Brian Bywater, who took the photograph of the 1957 train crash; Nigel Lloyd, who took the atmospheric sunrise shot of dancers on the summit of Eccles Pike, and Guy Martin, who kindly allowed me to use a few of his recent pictures to supplement my own photographs of present-day Chapel-en-le-Frith.

I should also like to thank all the following individuals who loaned photographs or gave me the benefit of their local knowledge: Stuart Ash; John Brook; Peter Burgess; Brian and Margaret Bywater; Roy Danson; Ian Durham; Bill Goddard; Harry and Joyce Hall; Frances Hibbert; Peter Harrison; Peter Helps; John Hodgkinson; John and Jennifer Kelly; Bryan McGee; Bob Mulholland; Enid Phillips; Emma Round; Jeanette Saxby; Sue Stockdale; David Sugden; Ann Young; and last, but certainly not least, my wife Jo-Ann.

Thanks are also due to the following organisations: Chapel-en-le-Frith High School; Chapel-en-le-Frith Primary School; Chapel-en-le-Frith Parish Council; Federal Mogul Ltd; and the King's Arms Hotel.

Any errors of fact are, of course, solely my responsibility.

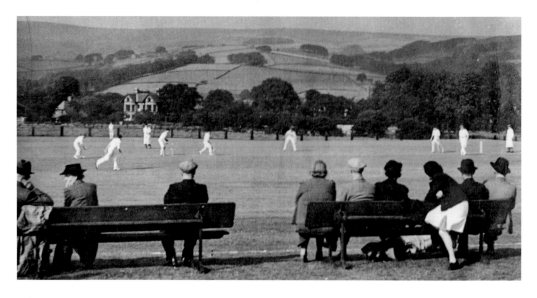

Chapel-en-le-Frith Cricket Club was formed in 1884. Even though many more houses have been built on the perimeter since this picture was taken, the cricket ground, which is accessed from Willow Road, still stands in an idyllic location below the long ridge of Combs Moss. Matches of Chapel's football club have been played on an adjacent pitch since 1960. The soccer ground has been christened 'Rowton Park'.